D1330530

Please return / renew by date shown.
You can renew at: **norlink.norfolk.gov.uk**
or by telephone: **0344 800 8006**
Please have your library card & PIN ready.

NORFOLK LIBRARY
AND INFORMATION SERVICE

NORFOLK ITEM

30129 069 549 856

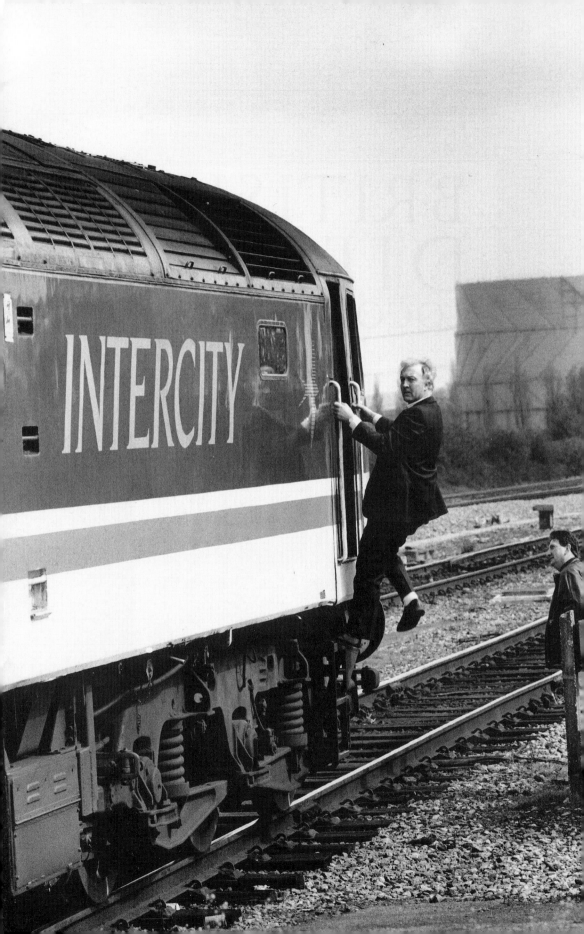

BRITISH DIESEL LOCOMOTIVES

DAVID HUCKNALL

The
History
Press

First published 2010, this paperback edition published 2012

The History Press
The Mill, Brimscombe Port
Stroud, Gloucestershire, GL5 2QG
www.thehistorypress.co.uk

British Library Cataloguing in Publication Data.
A catalogue record for this book is available from the British
Library.

ISBN 978 0 7524 7650 6

Typesetting and origination by The History Press
Printed in Great Britain

Contents

Introduction 7

Acknowledgements 9

1 English Electric Type 5/BR Class 55 The Deltics 11

2 English Electric 1Co-Co1 Type 4s/BR Class 40 21

3 BR Class 50 29

4 Sulzer Type 4 2,500hp locomotives/BR Class 45 43

5 Brush/Sulzer Type 4/BR Class 47 49

6 The 'Warship' Class/BR Class 42/43 69

7 'Western' Class 52 Diesel Hydraulics 79

8 InterCity 125/BR Class 43 HST 87

9 English Electric Type 3/BR Class 37 95

10 Clayton Type 1 diesels – the 'Claytons'/BR Class 17 103

11 Diesel Multiple Units (DMUs) 109

12 The Shunters 123

13 Heavy Freight Classes 131

14 BR Class 33 143

15 The Bo-Bo Electro-diesels/Class 73 155

Introduction

I still have a copy of *The abc of British Railways Locomotives Part 3* (Summer 1956 edition), bought when I was at school. The only 'diesels' listed occupied one page of the book in an appendix entitled 'Diesel Multiple Unit Trains'. I had the numbers of three 'motor CLs' underlined.

The relative numbers of steam locomotives and diesels in BR stock and their variation over several years were given by Preedy and Ford in their album, *BR Diesels in Close-up* (Bradford Barton, Truro). In 1959, for example, there were 1,799 diesels and 14,457 steam locomotives. By 1962, the numbers were 3,683 and 8,767 respectively and, for 1967, the split was 4,742 and 362.

Looking at these figures, the dieselisation of Britain's railways seems hasty and ill-thought-out. There had been a huge under-investment in Britain's railways during the Second World War and, unlike in many European countries, the opportunity to start again when repairing the structure afterwards was never taken. Work on steam locomotives had always been hard, dirty and sometimes dangerous and even with the acute post-war shortage of labour, it did not seem to be recognised that very significant changes had to be made. The relatively simple operation of the diesel locomotive – available almost at the press of a button – can still be regarded as a tentative step on the road to electrification.

This book is a collection of photographs that shows some of the classes of diesel locomotive covering the years from the early 1960s until the beginning of the 2000s. It is divided into fifteen chapters, reflecting many of the diesel locomotive classes (the Deltics, the Brush Type 4s (47s), the 'Warships', the 50s through to the Class 08 shunters and even the DMUs) that have maintained our system over that period. It is, necessarily, selective. It reflects my own preferences and, possibly, those of the contributors who have given me considerable help in the preparation of this album.

Acknowledgements

It gives me great pleasure to acknowledge those who have contributed to this book. I should particularly like to thank John Hillmer and Brian Errington; John for selecting photographs which fitted my requirements closely and Brian for printing my negatives so competently. I am also grateful to David Canning for allowing me to use some of his photographs. Finally, I should also like to acknowledge the contribution of the late W.A.C. Smith to this book. Bill Smith died in August 2009. He had helped me with material for all my railway books since the first was published in 1988 and his readiness to provide me with copies of his superb photographs will always be appreciated.

**English Electric Type 5/
BR Class 55
The Deltics**

The Deltics entered service between 1961 and 1962. Built by English Electric, they were designed for high-speed express passenger services on the East Coast Main Line between King's Cross and Edinburgh Waverley. Twenty-two units were built and they were powered by two Napier Deltic 18-cylinder engines, each with a power output of 1,650bhp (1,230kW) at 1,500rpm. The locomotives were assigned to three locomotive depots – Finsbury Park, Gateshead and Haymarket. During British Railways' summer schedules in 1963 and 1964, the fleet of Deltics covered a million miles in twelve weeks.

Originally, they were painted in a striking two-tone green livery – dark at the top with a lighter lime-green at the bottom. Initially, the Deltics did not have warning panels painted on their ends. Fairly quickly, however, they began to carry a yellow panel extending upwards from the buffer beam and including the four-character train description indicator. By 1966, the Deltics began to appear in the featureless 'Rail Blue'.

In the late 1970s, the Deltics began to be replaced on many services by the InterCity 125 units and the Deltics were then reduced to being a small, non-standard class of diesel locomotives for use on secondary services. The final run of a Deltic came on 31 December 1981 with the 16.30 Aberdeen–York which was pulled from Edinburgh by No. 50019 *Royal Highland Fusilier*.

..

Opposite, top: Standing at Platform 10 of Waverley station on 19 April 1965, at the head of the Up 'Flying Scotsman' (IA39), is Deltic No. D9004 *Queen's Own Highlander*. Assigned to three locomotive depots – Finsbury Park, Gateshead, and Haymarket – Deltics were soon given names. Finsbury Park named its allocation, in traditional LNER manner, after winners of 'classic' horse races, while Haymarket and Gateshead engines were named after British Army regiments.

Opposite, bottom: No. D9009 *Alycidon* (named after the winner of the 1949 Ascot Gold Cup, the Goodwood Cup and the Doncaster Cup) was assigned to Finsbury Park depot. Seen here just south of Bawtry with an Up train on the evening of 18 May 1964, it is one of six Deltics that were preserved after withdrawal.

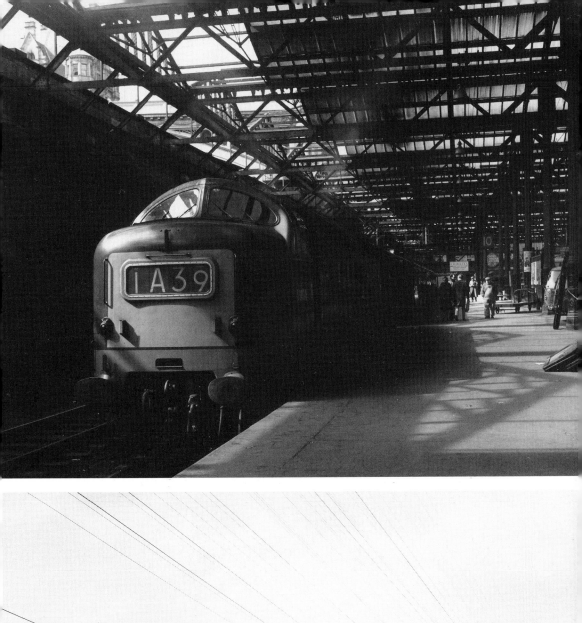

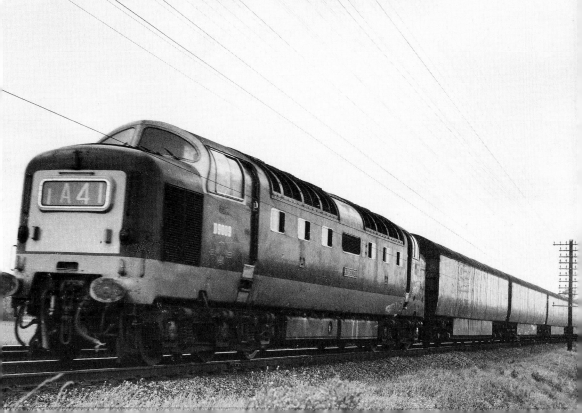

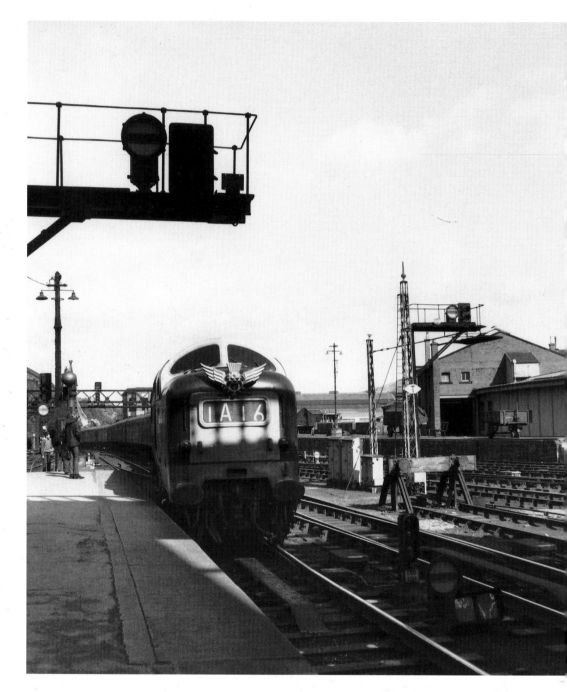

Entering Waverley station on the afternoon of 29 August 1964 with the Down 'Flying Scotsman' is an unfortunately unidentified Deltic. Above the train identification number is the stylish gilt winged thistle emblem that so complemented these impressive machines.

Opposite: On the Down main line at Ranskill (some 145 miles north of King's Cross), Deltic No. D900 *The Fife and Forfar Yeomanry* heads towards Bawtry and Doncaster on 26 April 1964.

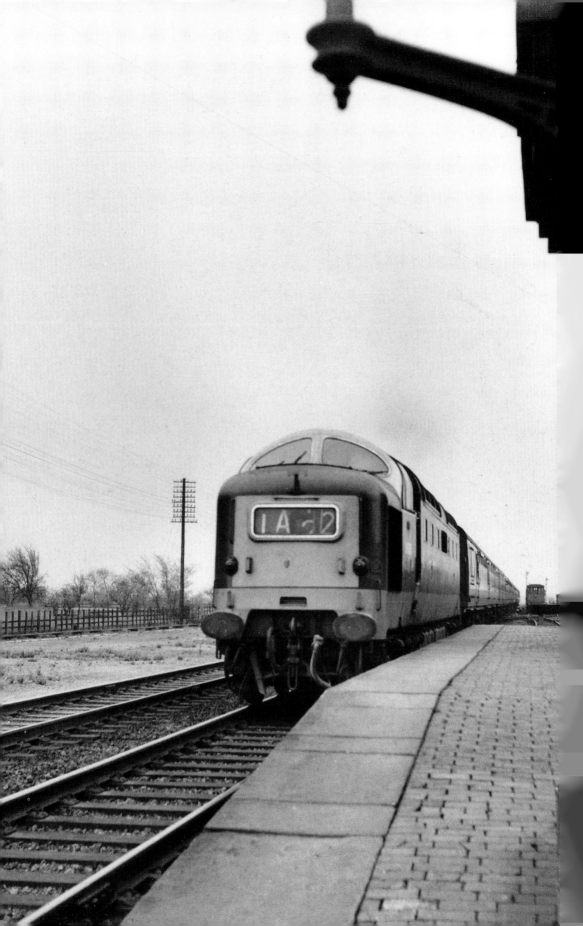

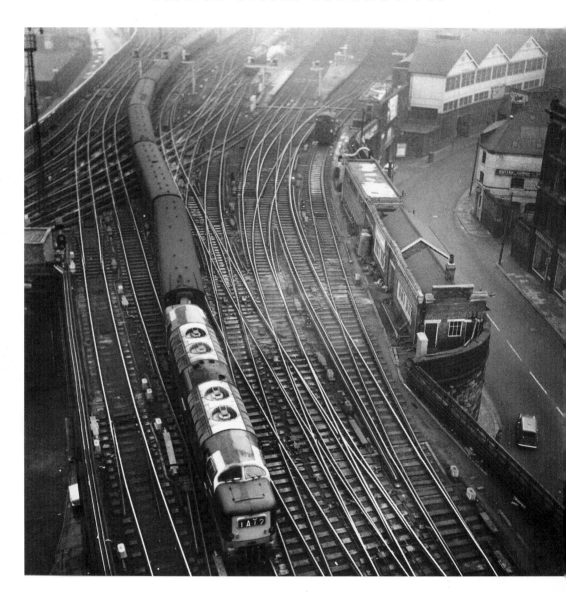

An unidentified Deltic leaves Newcastle Central station with 1A12 on a murky November afternoc in 1965. The once-famous diamond crossing, which allowed the Up and Down main lines and lin leading to the high level bridge to intersect, can be seen.

Opposite, top: With the appalling boiler wash-out dump between Ranskill and Scrooby as a backgroun Deltic No. D9018 *Ballymoss* heads a Down King's Cross–Edinburgh train on 16 May 1964. The hor Ballymoss was voted European Horse of the Year in 1958 and had also won the prestigious Prix (l'Arc de Triomphe.

Opposite, bottom: Deltic No. D9018 *Ballymoss* pauses at Doncaster station on the afternoon of 18 Ap 1964 with a King's Cross-bound train. This was very much in the period of transition between stea and diesel and, in the distance, a jet of steam is emerging from a stand-by locomotive. The preferenc for traction type may also have been reflected with the trainspotters on the platform. Some are seat(on a luggage trolley – waiting for better things – while others have a closer look at D9018.

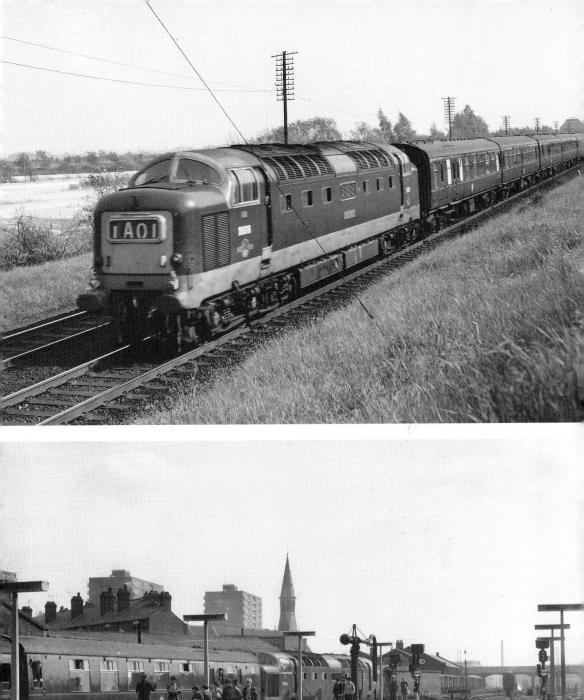
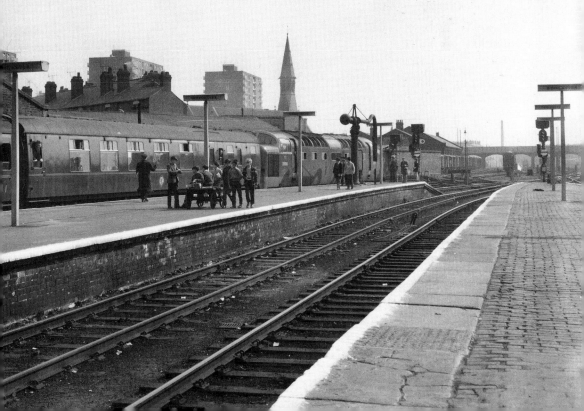

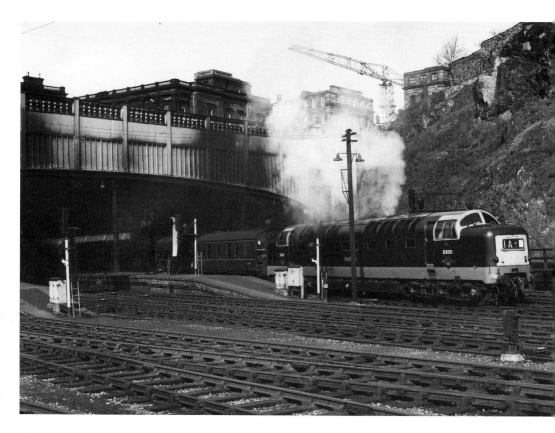

With the characteristic roar from the two Napier Deltic engines, No. D9001 *St Paddy* draws away fr
the Up main platform at Waverley station on 18 April 1965 with a train for King's Cross.

Opposite, top: Looking superb in British Rail blue, Deltic No. 55012 *Crepello* approaches the suburl
platform at Edinburgh to head the 16.45 'RPPR Deltic Pictorial' (1F55) from Edinburgh to King's Cr
on 24 September 1977. This was a special, from King's Cross to Edinburgh, organised in connect
with the BR (Scottish Region) Rail Festival at Haymarket depot. D9012 was withdrawn from servic
May 1981. *(D.E. Canning)*

Opposite, bottom: With Doncaster station in the background, an eye-catching BR Class 55 (Delt
No. 55007 *Pinza*, in Rail Blue, is travelling on the Up fast line towards Bawtry and the south on 13 N
1978. No. 55007 was withdrawn at the very end of 1981 and subsequently scrapped. *(J.C. Hillmer)*

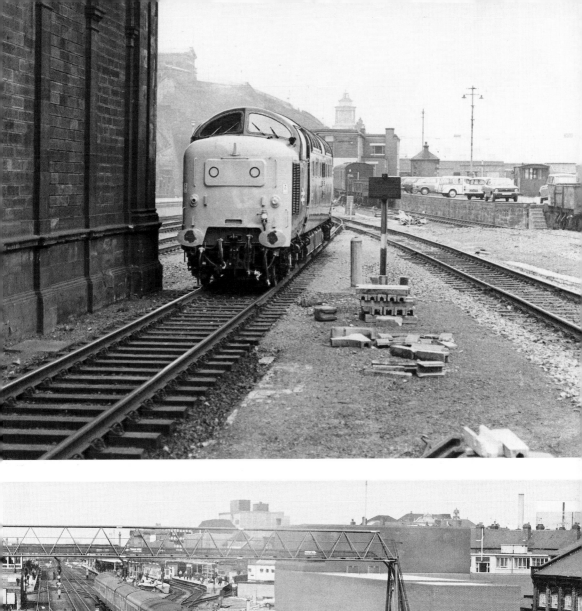
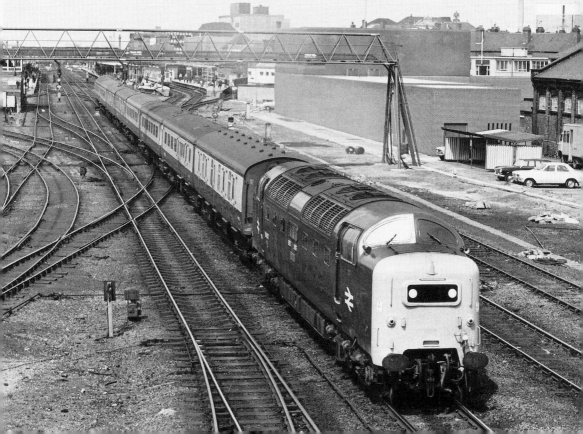

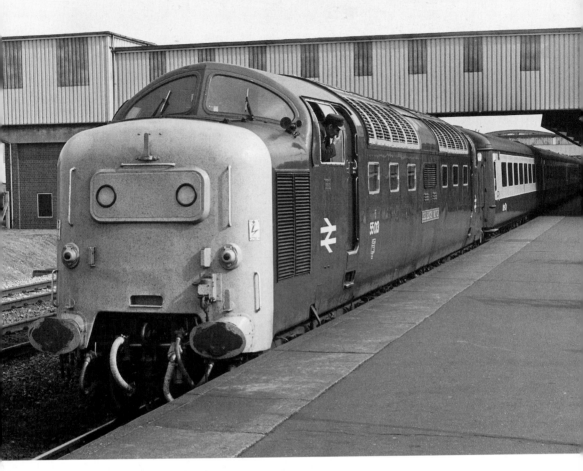

In spite of the vast numbers of insects attached to the warning panel, Class 55 No. 55013 *The Bla
Watch* looks eye-catchingly smart as it pauses at Platform 4 of Peterborough station on 17 June 198
with a King's Cross–York train. Its pensive driver reflects on who knows what, but probably n
on his official driver's cap. No. 55013 was withdrawn on 20 December 1981 but was not preserve
(J.C. Hillmer)

2

**English Electric 1Co-Co1
Type 4s/BR Class 40**

British Railways initially ordered ten Type 4s from English Electric as prototypes for evaluation. They were built at Vulcan Foundry. No. D200 was delivered in March 1958. Of the prototypes, Nos D200–204 worked on the former Great Eastern routes while Nos D205–209 worked on GN services on the East Coast Main Line.

The prototypes having been successful, BR ordered another 190 locomotives (D210–399). All, except Nos D305–324 which were built by Robert Stephenson and Hawthorn's in Darlington, were built at the Vulcan Foundry.

The first 125 locomotives (D200–324) had 'disc' headcodes reflecting the traditional British Railways steam locomotive practice for train-type identification. Locomotive Nos D210–235 were given the names of liners operated by shipping companies such as Cunard, Elder-Dempster and Canadian Pacific, probably because they hauled expresses serving Liverpool (the home port of Cunard and Elder-Dempster and used by Canadian Pacific).

The Class 40s operated in most areas of BR with the exception of the Southern and Western Regions. The majority were based at depots such as Kingmoor, Longsight and Gateshead.

Opposite, top: At King's Cross station, the driver of English Electric Type 4 No. D209 and the guard in discussion. D209 entered service at Hornsey shed in 1958 and was one of the five prototypes th worked on the ECML. The EE 1Co-Co1 units D200–209 also performed with credit on the Liverp Street–Norwich line. C.J. Allen, a prolific railway commentator at the time, had experienced 'one the fastest exits from Liverpool Street behind D202 + 307 tons,' arriving at Chelmsford in just o 29 minutes. D209 (later No. 40009) was withdrawn in 1984 and scrapped at Doncaster. *(H.G. Usn D.J. Hucknall Collection)*

Opposite, bottom: Some of the English Electric Type 4s were given names. These were names carr by some of the liners that served the Port of Liverpool. The cast nameplates carried not only the na of the vessel but, rather like Bulleid's 'Merchant Navy' class, gave the company name and show its houseflag. This photograph, taken at St Margaret's shed in June 1965, shows the name carried No. D233 *Empress of England*.

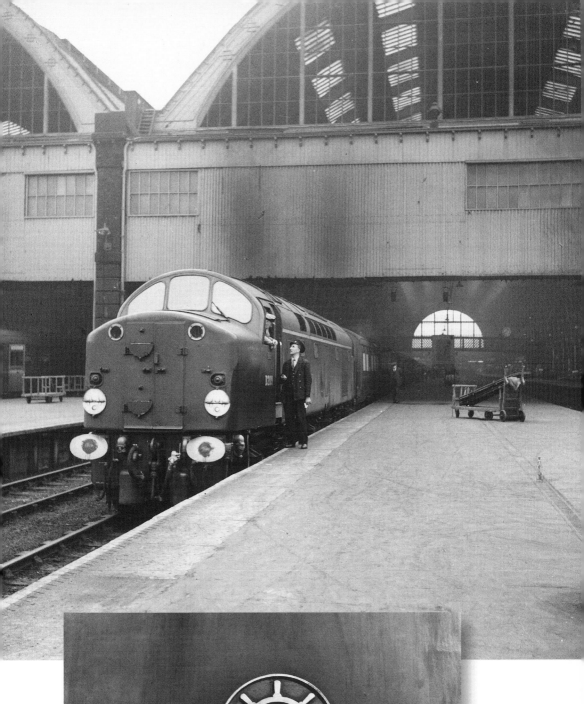

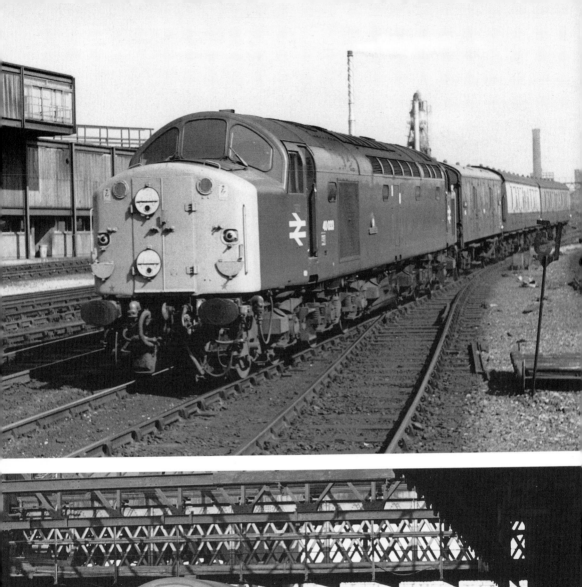

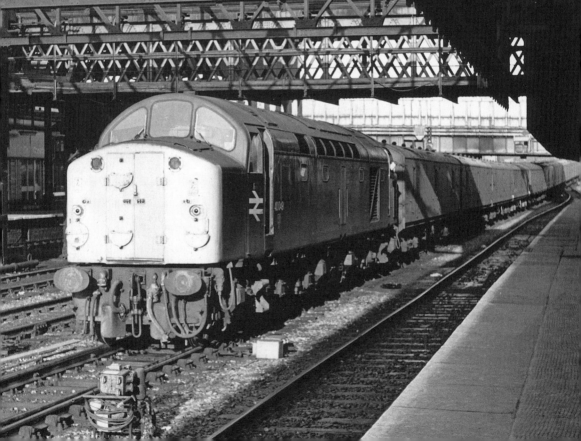

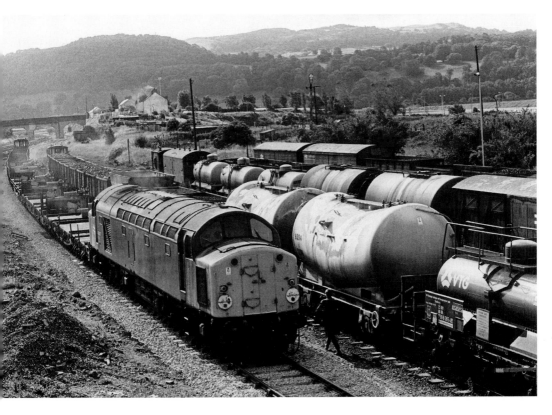

view to the east over the railway yard at Llandudno Junction on 2 July 1983 shows Class 40 . 400047 (formerly No. D247) heading an empty civil engineer's train. The siding is located alongside station and although it was reportedly intact in 2006, the tracks were overgrown with bushes and ubs. *(J.C. Hillmer)*

posite, top: Some nine years after my photograph on page 23, John Hillmer caught No. D233 (by now . 40033) *Empress of England* as the locomotive entered Manchester Victoria on 18 September 1974 h a parcels train from the east. No. 40033 was withdrawn in 1984 at Doncaster Works. *(J.C. Hillmer)*

posite, bottom: Class 40 No. 40049 (formerly No. D249) enters Manchester Victoria with a west-bound rcels train on 26 February 1977. The locomotive entered service in 1959 and was withdrawn some enty-four years later at Crewe Works. *(J.C. Hillmer)*

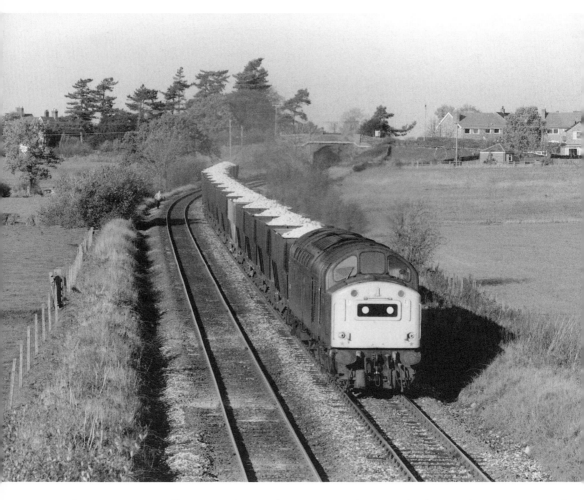

EE Class 40 No. 40181 (formerly No. D381) is seen at Ashley in Cheshire with a Buxton–Northwi
limestone train on 10 November 1984. Ashley is on the Altrincham–Chester line between Mobber!
and Hale stations. No. D381 was built in 1962 and had a centre panel on the ends of the locomotive
was withdrawn shortly after this photograph, in January 1985. *(J.C. Hillmer)*

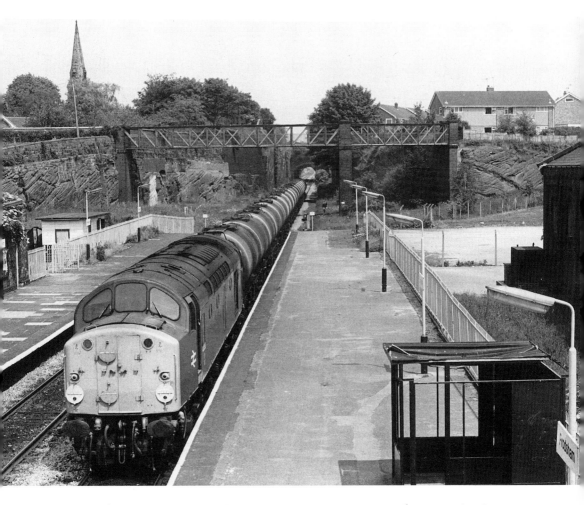

Class 40 No. 40093 heads west towards Ellesmere Port on 21 June 1983 with a train of tank wagons. e train is seen at Frodsham station on the Runcorn–Helsby line. The station building at Helsby hich would be to the left of the area shown), although now unused, is a Grade II listed building. . Hillmer)

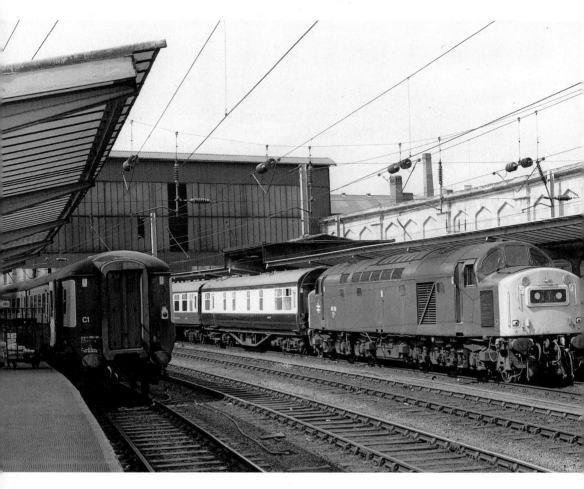

This view of Carlisle station on 19 July 1984 shows EE Type 4 No. 40150 (formerly No. D350) at head of the 'McAlpine Charter' that worked from Scotland to the south via the Settle to Carlisle ro No. 40150 was withdrawn from service the following year.

3

50009

BR Class 50

The Class 50 was based on English Electric's locomotive DP2 (Diesel Prototype 2), a Type 4 main line locomotive built in 1962 by EE at its Vulcan Foundry as a demonstration unit. BR initially tested DP2 on LMR services before transferring it to the Eastern Region in July 1963 when Deltics required train-heating boiler modifications on a one-by-one locomotive basis. The operating loss was covered by rostering DP2 (a 2,700hp locomotive) to a Deltic (3,300hp) diagram.

Over fifty-eight consecutive days, DP2 covered 43,000 trouble-free miles. Its brilliant career was ended on 31 July 1967 when it collided with a derailed wagon near Thirsk. It was returned to Vulcan Works in September 1967 where it was deemed beyond economic repair.

Following its success, BR placed an order for fifty units (the D400s, later Class 50). Initially leased by EE Leasing Ltd, the agreement guaranteed 84 per cent availability. Crewe depot was the main operating base although spare locomotives were available at Crewe, Carlisle and Polmadie.

From 1973 onwards, the locomotives were numbered in the range 50001–50050 to conform with the TOPS scheme; D400 became 50050.

A gratifying decision was made in the late 1970s to give names to Class members. The first, No. 50035, received its name on 17 January 1978. The last to be named was No. 50006 in September 1979.

..

Opposite, top: Here, on 25 April 1973, No. 449 is seen passing Pollockshaws West with the 13.40 fr Glasgow Central to Euston. The train had been diverted over the former GSWR line because electrification work on the WCML. *(W.A.C. Smith)*

Opposite, bottom: In this view taken from the west, Class 50 No. 436 (later named *Victorious*) is s passing Crossmyloof station with the 13.10 relief from Glasgow Central to Euston via Kilmarnock 25 April 1973. Crossmyloof was an intermediate station on the St Enoch to Kilmarnock main line of GSWR. The overline building, the front of the booking office, was removed in the 1990s although station remains in regular use. *(W.A.C. Smith)*

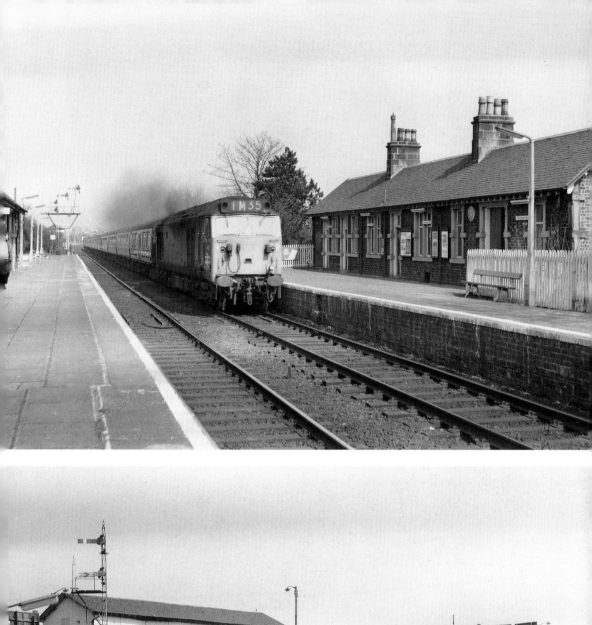
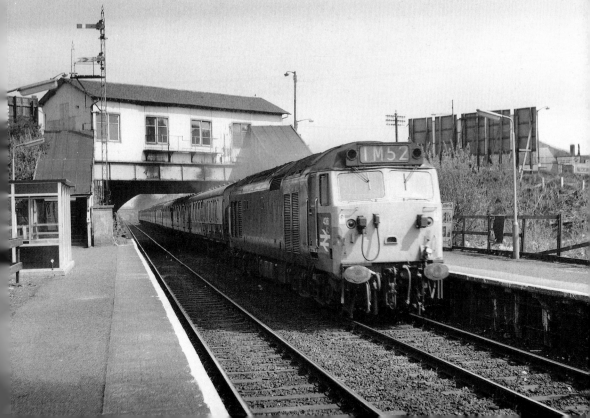

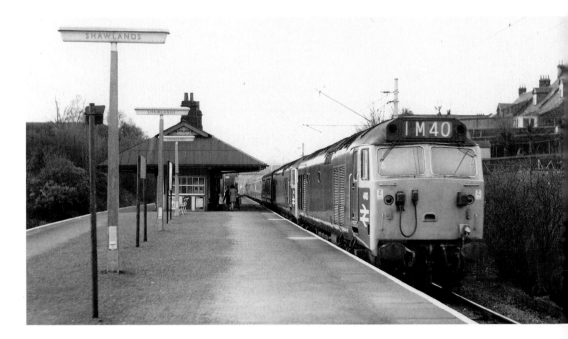

On 7 April 1973, Class 50s Nos 440 and 408 are photographed at Shawlands station on the Catho
Inner Circle with the 17.25 from Glasgow (Central) to Liverpool and Manchester. The train had be
diverted from the main line because of electrification work. *(W.A.C. Smith)*

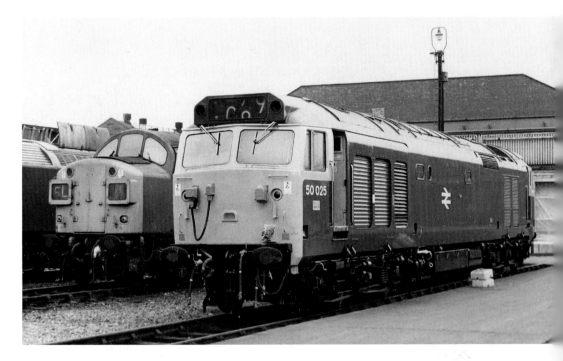

In 1974, the West Coast Main Line was electrified and the Class 50s were transferred en masse to
Western Region where they worked from Paddington to Oxford, Plymouth, Penzance and Bri
Probably because it was in the works at the time, No. 50025 (later named *Invincible*) is seen at Cr
Works in superb condition on 15 December 1974. *(J.C. Hillmer)*

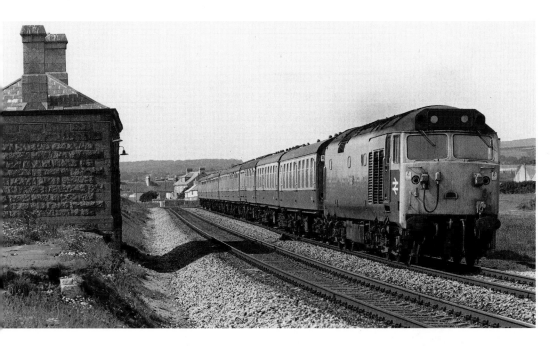

er they had been displaced on the WCML by the Class 87 electric locomotives, the Class 50s were
nsferred to the Western Region. Here No. 50037 *Illustrious* is seen passing Marazion with the 12.35
1zance–Swansea service on 15 September 1979. *(J.C. Hillmer)*

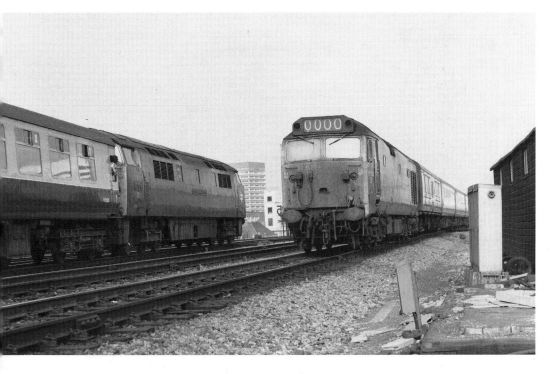

fortunately undated, Type 50 No. 50044 (then unnamed) is seen passing Class 52 No. D1070 *Western
1ntlet* near Reading. For the record, No. D1070 was scrapped at BREL, Swindon, in May 1979.
E. Canning)

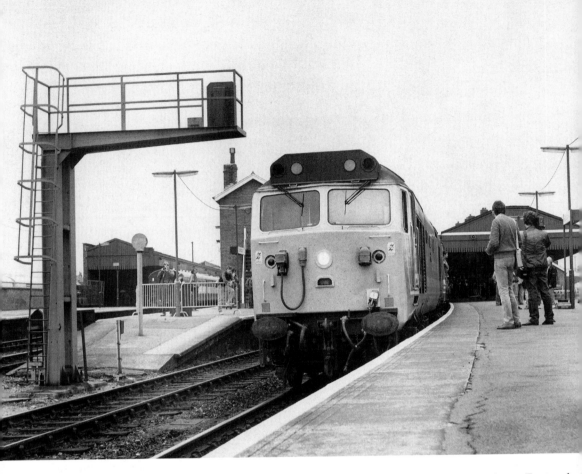

Laira's Type 50 No. 50037 *Illustrious* (formerly No. D437) accelerates a Down train to Exeter fro
Platform 4 at Salisbury station. The date was 20 June 1987.

Opposite, top: Eighteen Type 50 locomotives have been preserved including No. 50050 *Fearless* (forme
No. D400). Here, at an open day at Bournemouth Traction and Rolling Stock Maintenance Dep
No. 50050 is seen in BR Large Logo livery.

Opposite, bottom: Probably wondering just what his father's enthusiasm for trains is based on, my s
Philip looks closely at Class 50 No. 50027 *Lion* as it stands in the engine siding behind Platform 5
Salisbury. *Lion* was given its name at Laira shed in April 1978 after the battlecruiser.

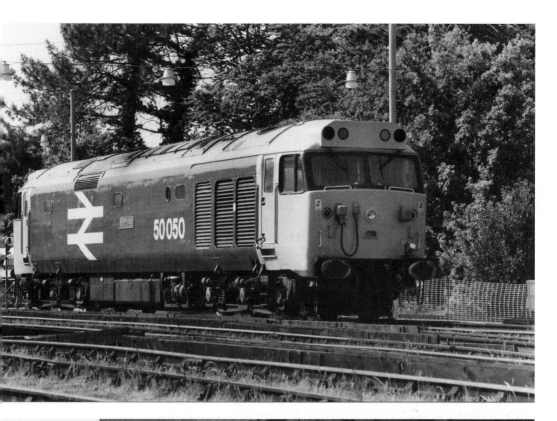

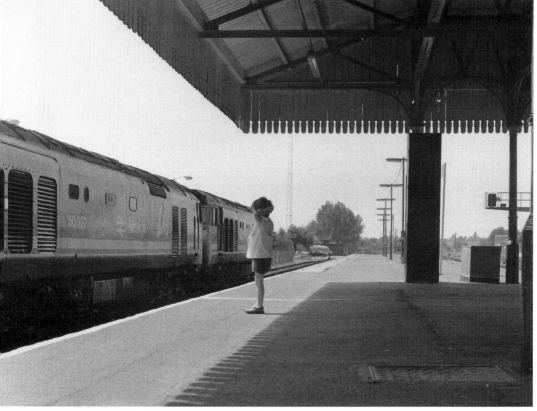

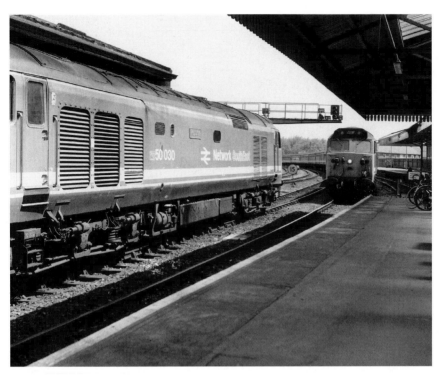

Type 50 No. 5003
Repulse stands
at Platform 3 at
Salisbury station
while a sister
engine approache
Platform 4 on the
Down main line.
Repulse was name
after a 'Renown'
Class battlecruise
but the name had
also been carried
'Jubilee' class
No. 5725/45725
from September
1936 until its
withdrawal in 19

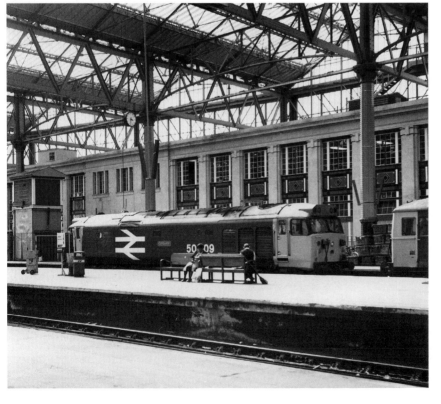

According to the
platform clock, it
was 3.30 p.m. wh
this photograph
Class 50 No. 5000
Conqueror was ta
at Waterloo static
on a Sunday in
May 1987. In 198
a revised livery
was adopted by
Doncaster Works
for the 50s, with
yellow cab ends,
large body-side
numerals and the
BR 'double-arrow
logo. Here,
No. 50009 is seen
the livery which
suited the class.

...ve a great
...ng for
...otographs
...ocomotives
...profile.
...re, with the
...ster's seagull
...parently
...ring through
... windscreen,
...lass 50 stands
...Platform 3 of
...isbury station
...aiting its next
...cy.

...anuary 1978, the decision
...s made to name the Class
...locomotives and No. 50035
...s given the name *Ark
...al* in honour of the aircraft
...rier HMS *Ark Royal*. On
...February 1995 (the fiftieth
...iversary of the death of
...Edward Elgar), No. 50007,
...n *Hercules*, was renamed
...*Edward Elgar* and painted
...l lined out in the style of the
...mer Great Western Railway.
...his photograph taken
...alisbury, the nameplate
...hown together with the
...que stating, 'Great Western
...lway Company'.

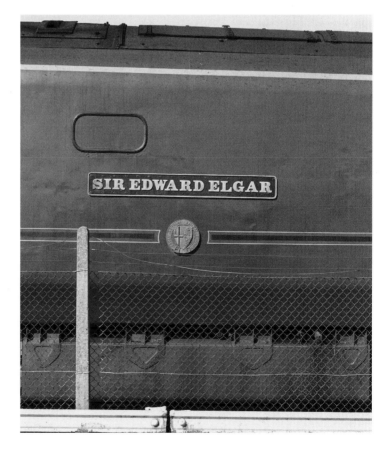

Type 50s and a Type 47 are seen in the west bay at Salisbury station. With its former number (417) still displayed at the front of the cab, No. 50017 *Royal Oak* seems to have attracted a butterfly to its multiple working socket.

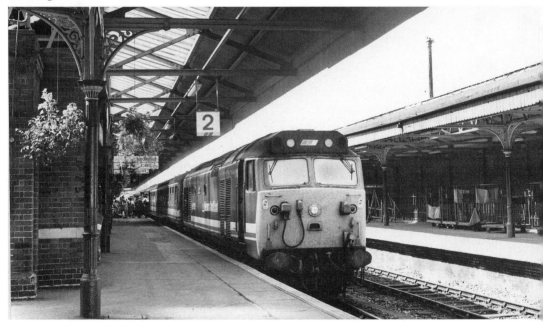

It was always a pleasure to be at Salisbury station in the late 1980s, particularly in the summer. The platforms were spotlessly clean and the awning supports were always decorated with hanging baskets. This is clearly shown as Class 50 No. 50029 *Renown* stands at Platform 2 where business seems brisk for the 14.21 departure to Waterloo.

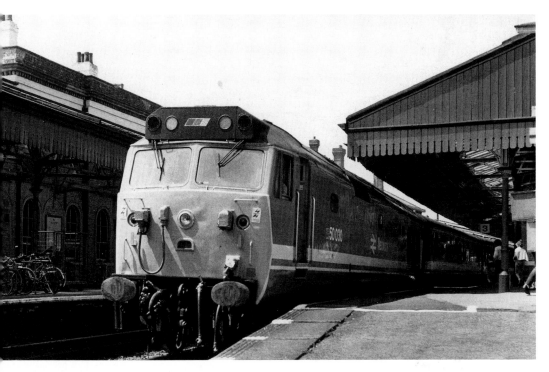

ass 50 No. 50030 *Repulse* waits at Platform 3 at Salisbury station to work the 13.20 Salisbury to
terloo on 29 May 1989.

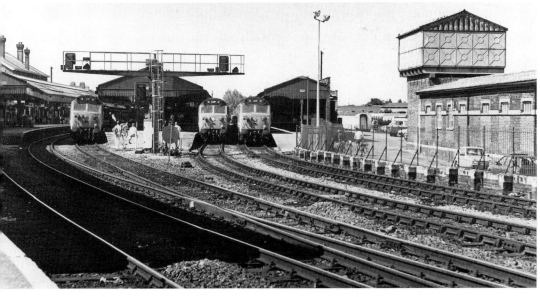

panoramic view of Salisbury station on 28 August 1989 from Platform 6 shows Class 50s at Platforms
2 and 3. The locomotives involved were No. 50003 *Temeraire* (Platform 3), No. 50027 *Lion* (Platform 2)
d No. 50041 *Bulwark*. At the beginning of the 1990s, the reliability of the Class 50s became a problem.
ey were probably unsuited to the several starts and stops associated with the Salisbury–Exeter line
d, if breakdowns occurred on a part of the line which was singled, major hold-ups occurred. Of
three locomotives shown, No. 50027 is preserved while No. 50003 was scrapped in May 1992 and
. 50041 was also broken up.

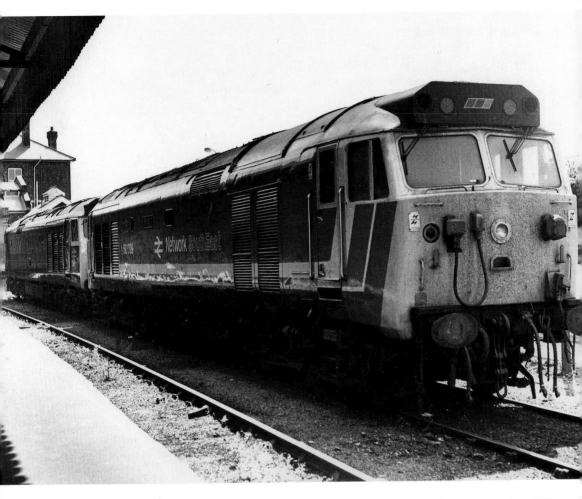

In the West Engine Siding at Salisbury on 18 June 1989, two Class 50s, No. 50007 *Sir Edward Elgar* an
No. 50029 *Renown*, wait for further duties. No. 50029 remained in original Network South East live
and No. 50007 was in its GWR colours.

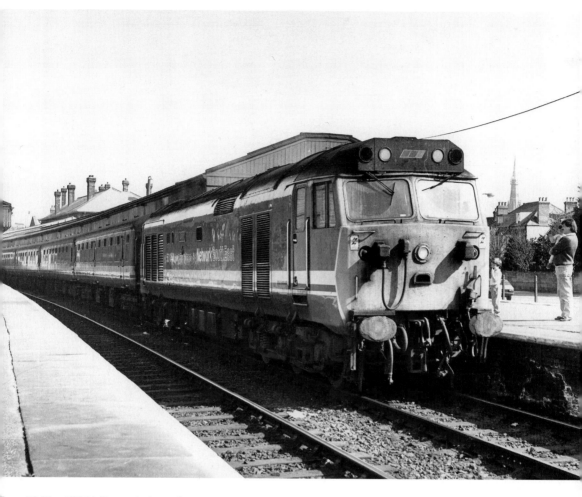

Class 50 No. 50044 *Exeter* brings the 14.41 to Exeter into Salisbury station on 1 April 1990. The train was thirty minutes late! No. 50044 is one of several Class 50s which are now preserved. It was restored as No. D444 and, as recently as 2005, it was to be seen in two-tone green livery on the Severn Valley Railway and is registered for use on the main line.

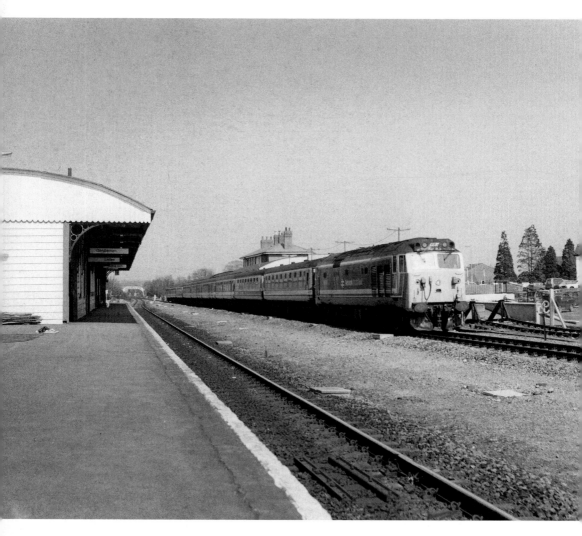

Andover station is 107km (about 66 miles) south-west of Waterloo on the line to Exeter. The stati
was opened in July 1854 and was an important link on the MSWJ Railway. Here, No. 50018 *Resolut*
is seen passing through the station with an Exeter-bound train on 24 April 1988.

4

Sulzer Type 4
2,500hp locomotives/
BR Class 45

L ate in 1957, after the decision had been taken to eliminate steam working completely from the Midland division of the London Midland region, the requirements of that division for long-distance passenger, express freight and mineral services was considered. As a result, in the 1960 Building Programme, 122 Type 4 locomotives were authorised. The result was that the Class 45 (also known as the Sulzer Type 4) locomotives were built by British Rail at their Derby and Crewe Works between 1960 and 1962. Initially, complications arose because the diesels were being delivered in advance of the installation of maintenance facilities.

The introduction of the first batch of 'Sulzers' also drew attention to difficulties in operating the existing schedules. For example, it was found that they could easily maintain the fastest steam schedules and frequently ran ahead of time, leading to a demand for the diesels to be diagrammed to the leading trains in groups of services before sufficient locomotives and trained crews were available. Their consistently good timekeeping eventually led to their use on, for example, through-workings between Bristol and Newcastle.

By the early 1970s, fifty examples were fitted with electric train heating, instead of steam heating boilers, and worked services on the Midland Main Line from St Pancras to Nottingham, Derby and Sheffield. In the case of the St Pancras–Sheffield service, 'The Master Cutler' became a preferred service for travel between South Yorkshire and London.

...

Opposite, top: Sulzer Type 4 (later Class 46) No. 180 is seen passing Gorbals Junction with the 13. Parcels to Edinburgh Waverley on 7 June 1973. At Gorbals Junction, the former City of Glasgo Union line and the Glasgow, Barrhead and Kilmarnock Junction railway met. The appalling high-ri flats, which were under construction at the time as a replacement for the Gorbals tenements, we demolished in 2008. The unusual tower in the left background is the former Caledonia Road Chur(*(W.A.C. Smith)*

Opposite, bottom: BR Sulzer Type 4 No. D24, with shining dark green livery, stands in the shed yard Corkerhill Motive Power Depot on 5 May 1961. Then, they still dominated British Railways. As if emphasise this, in the near background can be seen one of the ubiquitous 'Black 5' class, while near the Sulzer is one of Corkerhill's 'Jubilee' class engines – No. 45727 *Inflexible. (W.A.C. Smith)*

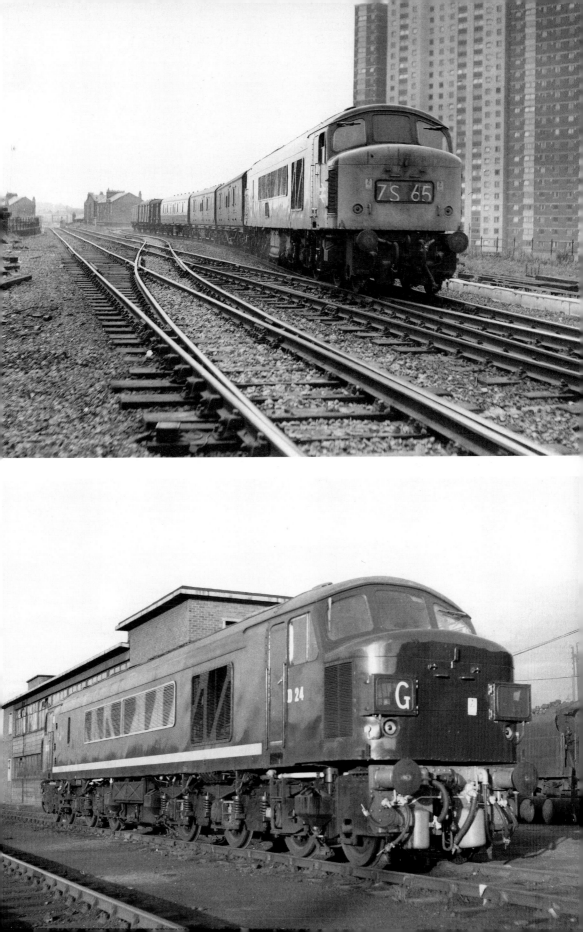

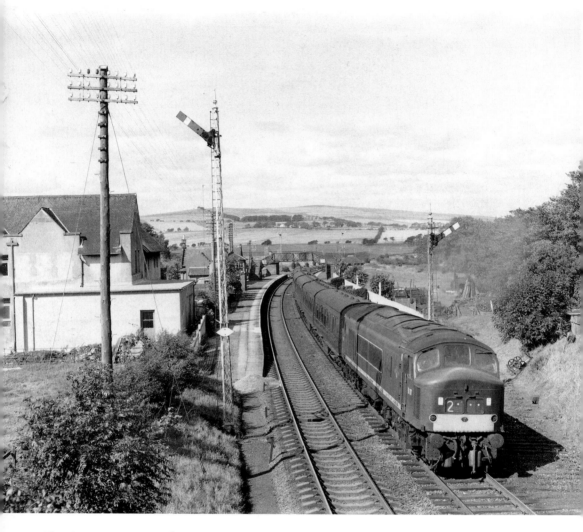

Thankerton, in Lanarkshire, was a station between Symington and Carstairs. Here, BR Sulzer Type No. D117 (later No. 45067) is seen heading the 12.25 p.m. from Glasgow Central to Lockerbie 12 September 1964. The station is now closed – the platforms removed – and Thankerton is now in t county of South Lanarkshire. *(W.A.C. Smith)*

Opposite, top: Seen at an open day at Bristol Bath Road in October 1965 are BR Sulzer Type 4 No. D1 (later Class 45 No. 45103) and an example of a Class 14 diesel hydraulic shunter, No. D9527. No. 45103, the Sulzer was withdrawn on 2 August 1988. It was later scrapped at MC Metals, Glasgo in March 1990. *(D.J. Hucknall Collection)*

Opposite, bottom: Sulzer Type 4 No. D29 climbs Neilston bank with the 18.38 p.m. Car Sleeper fro Glasgow (St Enoch) to Marylebone on 9 September 1963. In September 1984, as No. 45002, t locomotive was withdrawn from service. Four years later, in November 1988, it was scrapped by M Metals, Glasgow. *(W.A.C. Smith)*

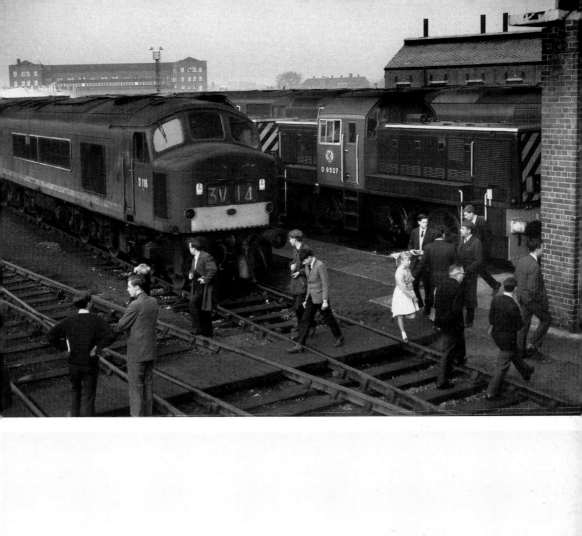

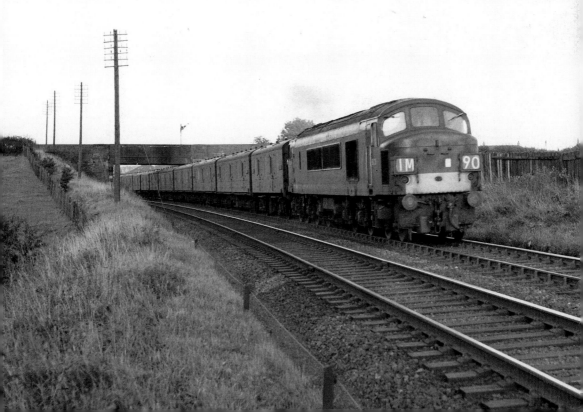

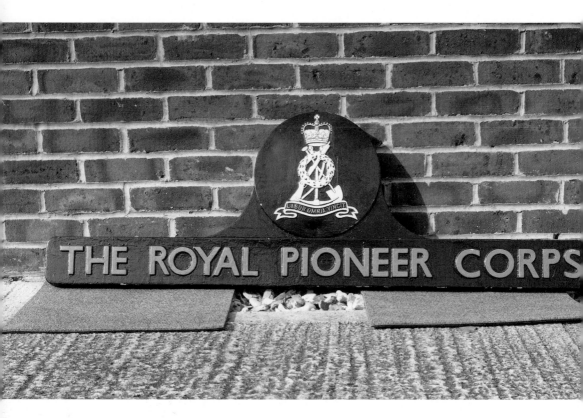

In the tradition of Britain's railways, some of the Sulzer Type 4s were given regimental names. Here the nameplate of No. D54 (No. 45023) *The Royal Pioneer Corps* is seen at the regimental museum near Aldershot. It gives me pleasure to acknowledge the assistance I received taking this photograph.

5

Brush/Sulzer Type 4/
BR Class 47

The Brush Type 4 diesel-electric locomotives were the most powerful (2,750hp/2,050kW) single-engine diesels to enter main line service in Britain. They were later de-rated to 2,580hp to improve reliability.

The class was developed by Brush Traction Division of Brush Electrical Engineering Co. Ltd of Loughborough and 512 locomotives were built between 1962 and 1968, either at Brush's Falcon Works or under licence in BR workshops at Crewe (202 units). Incorporating Sulzer 12LDA28 engines, the Type 4 was adopted as BR's standard high-powered diesel-electric locomotive.

The initial builds (nos D1500–1519) were mechanically different to the following locomotives and these were withdrawn first. In the early 1970s, the fleet was renumbered and became the Class 47. By this system, sub-classes could be created and those units fitted with certain equipment could be easily identified. For example, the 47/0 locomotives had steam-heating while the 47/3 sub-class had no train heating and so on.

By 1986, only five of the class had been withdrawn and these had all received serious damage in accidents. However, new locomotive classes were being delivered and the work available for the 47s began to decline. This allowed BR to withdraw non-standard locomotives (because of spare-part availability problems). Nevertheless, even by the end of 1992, only sixty-one members of the class had been withdrawn.

Eventually, for the period 1996–2006, an average of fifteen locomotives per year were being withdrawn. Even after forty years, however, there are reported to be more than 100 of the type in existence with thirty-one working on the main line.

..

Opposite, top: A stiff westerly breeze bends the poplar trees close to the ECML near Ranskill on a M evening in 1964, as Finsbury Park's Brush Type 4 No. D1547 rushes past with a Down train. It beca Class 47 No. 47432 in July 1974. Never named, it was scrapped in September 1995.

Opposite, bottom: Brush Type 4 No. D1958 entered traffic in February 1967 and was allocated to D (the Stoke-on-Trent division). Here, it is seen passing Fauldhouse (North) on 18 August 1972 with 12.15 FSO from Edinburgh Waverley to Manchester via Shotts and Motherwell. The locomotive v later renumbered and became No. 47512. It was scrapped in May 1994 in Rotherham. *(W.A.C. Smith*

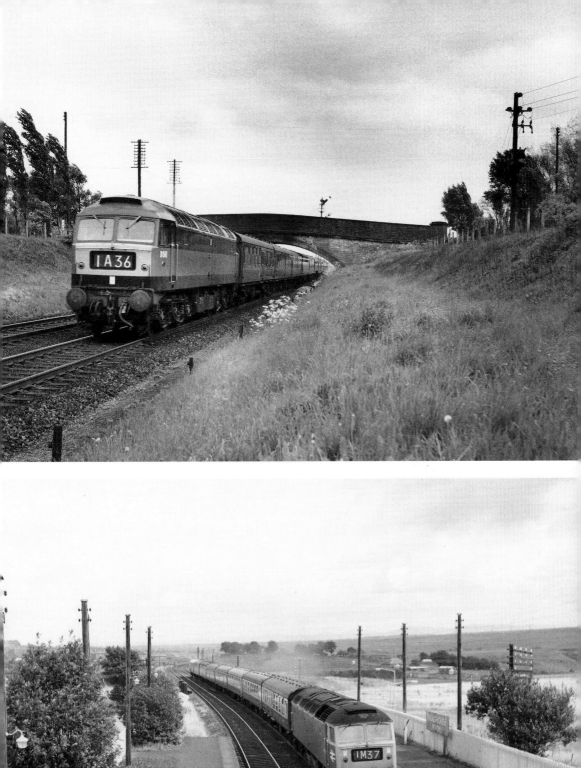

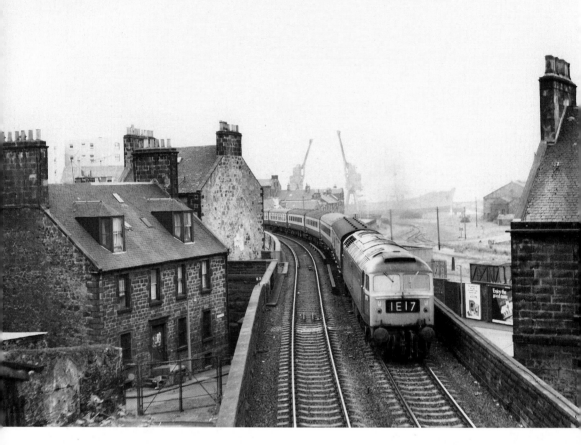

Passing through Burntisland on 25 August 1972 with the 10.30 Aberdeen to King's Cross is Brush Typ
No. D1975. At the time, the locomotive was a Haymarket engine, having entered service from the same sh
in November 1965. It was named *Andrew Carnegie* in August 1985, a name it retained until December 19
Eventually, after forty-three years of service and, as No. 47758, it was cut-up at Booth Roe in Rotherham
April 2008. *(W.A.C. Smith)*

Opposite, top: Heading an Up Anglo-Scottish Car Carrier on 16 May 1964, Brush/Sulzer Typ
No. D1546 passes Ranskill on the ECML between Bawtry and Retford. Entering traffic in October 19
it was soon transferred to Finsbury Park. It was renumbered in March 1974 and became No. 470
From May 1987 until October 1990, it carried the hardly inspiring name *The Toleman Group*. Better w
Atlas, the name it received in March 1994.

Opposite, bottom: The Class 57 locomotives were basically rebuilds of Class 47s. After redunda
locomotives of the latter class had been stripped, they were re-wired and re-engined by Brush
Loughborough. They were introduced between 1997 and 2004. Here, a member of the class, No. 570
Freightliner Pioneer (formerly D1875 and subsequently Class 47 No. 47356 and rebuilt by Brush in
first half of 1998), stands at the Freightliner locomotive stabling point, located close to Dock Gate 20
Southampton Container Terminal.

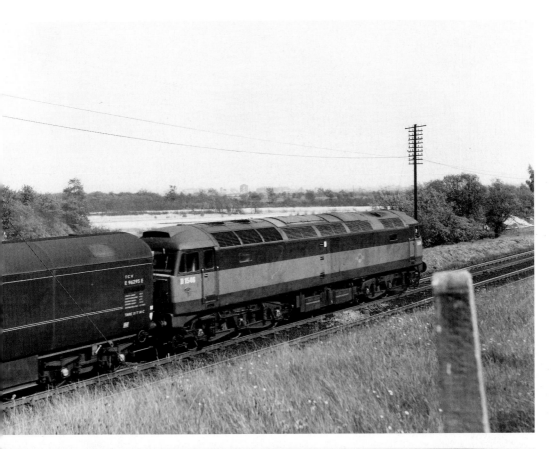

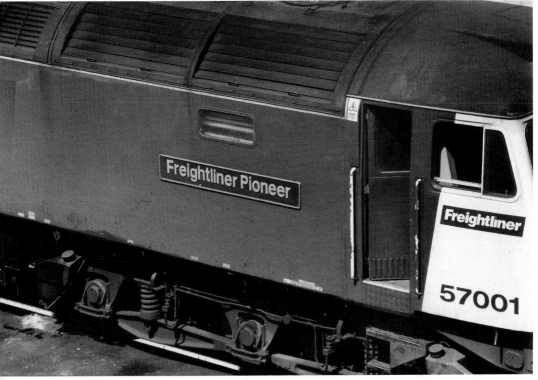

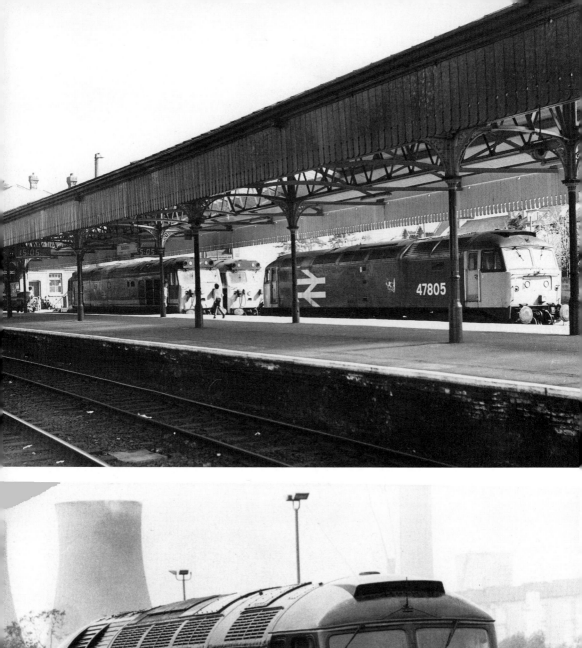

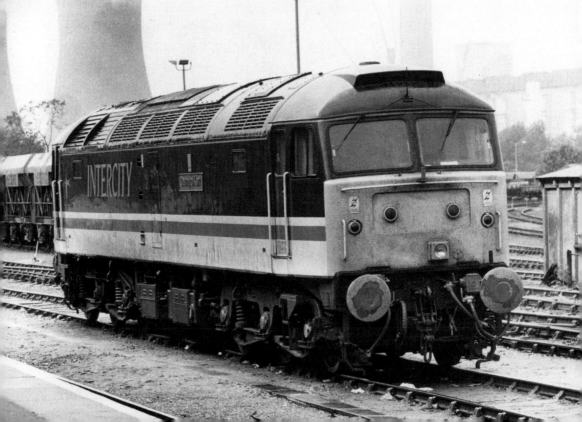

pair of Class 47s pass Par
tion on the Up line from
Blazey on 1 September
9. No. 47749 *Atlantic
lege* had entered service
ne thirty-four years
lier as No. D1660 and
gan work from Landore
oot, Swansea. As D1660,
vas renamed *City of Truro*.
l retaining its name,
660 became No. 47076 in
e 1965. Another name
ange took place in October
en it became *Resplendent*.
e name *Atlantic College
s* given to the locomotive
Queen Noor of Jordan.
. 47749 appears to still be
erational.

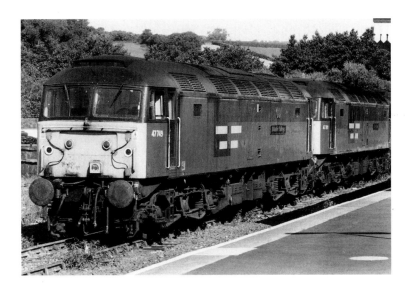

ish Type 4 No. D1675
azon is shown here at
isbury shed in 1966.
ilt by British Railways, it
ered traffic in April 1965.
tially, it was allocated
Canton depot, moving
Bristol Bath Road the
lowing year. In June
'4 it received the number
089. Thirteen years later,
February 1987, it was
rolved in an accident and
maged 'beyond practical
air'. (*George Harrison/D.J.
cknall Collection*)

posite, *top*: On 1 April 1990, Bristol Bath Road's Class 47 No. 47805 stands in the stabling point
hind Platform 5 at Salisbury station. Built at Brush's Falcon Works, it entered traffic as No. D1935
March 1966 at Bath Road shed. It was renumbered (to 47650) twenty years later and acquired its
. 47805 identity in August 1989. It remains operational, working from Crewe, after over forty years
service.

posite, *bottom*: In InterCity livery, Class 47 No. 47845 *County of Kent* is awaiting its next duty at
dcot station on 9 June 1991. Built at BR in Crewe Works as D1653, it entered service at Canton depot
16 January 1965. As No. 47638, it was named by Robin Leigh-Pemberton (the then Lord Lieutenant
he County). It was renumbered as 47849 in December 1989 and it retained its name. The locomotive
s rebuilt as Class 57 No. 57301 in July 2002.

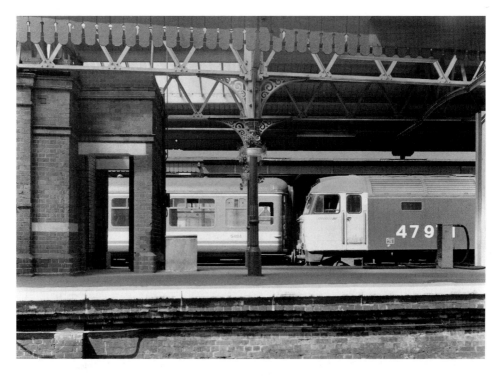

The LSWR station at Salisbury opened in May 1859 and a second platform was opened in the 1870s. Standing at Platform 1 is Type 47 No. 47971 *Robin Hood*. In the foreground is Platform 4 and, beyond, Platforms 3 and 2. Of No. 47971, it entered service as D1616 at Nottingham at the end of September 1964 and became No. 47971 in July 1989. It was scrapped in November 2001.

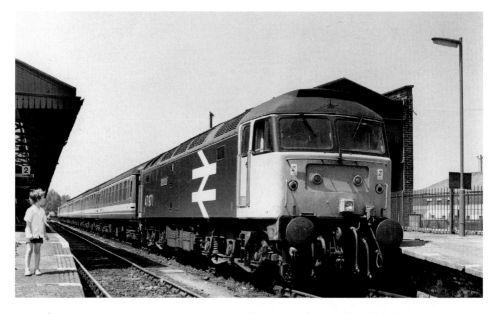

A further view of Class 47 No. 47971 standing at Platform 1 of Salisbury station on 19 September 1989 is shown. The small boy (my son) was actually well supervised, other members of the family waiting to sweep him up should another step be taken.

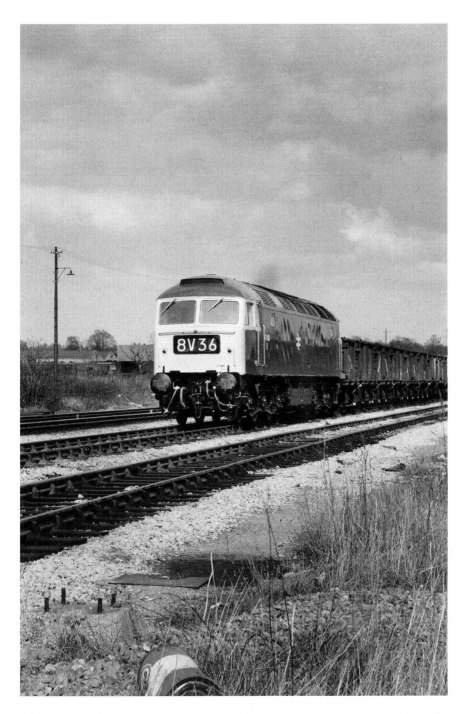

BR's 'Rail Blue' corporate livery was a 'dark greyish blue tone which hid the dirt well.' The colour was applied to all diesel and electric locomotives with the exception of the ends, of course, which were yellow to improve the visibility of the locomotives. Looking superb in 'Rail Blue', Class 47 No. 47456 is photographed near Derby on the Birmingham line. New in April 1964 (formerly D1576), it was allocated to Gateshead. It moved further south (to Finsbury Park) on loan in July 1965 and thereafter was assigned to Tinsley, Immingham and Stratford. It was withdrawn in September 1991. (D.J. Hucknall Collection)

Below: On the evening of 30 August 1990, Class 47 No. 47625 stands at Platform 2 at Hereford (serving the Down main line). At the time, the locomotive was in InterCity livery with its dark grey upper body, an off-white lower body and horizontal red and white stripes. The locomotive had entered service in February 1965 as D1660 and it was assigned to Landore shed, Swansea. From November 1984 until November 1995, it became No. 47625 and carried the name *City of Truro*. In later renamings, it became *Resplendent* and *Atlantic College*.

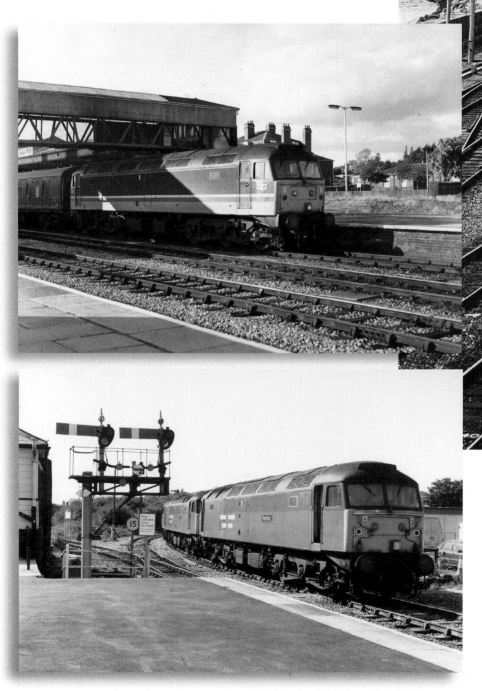

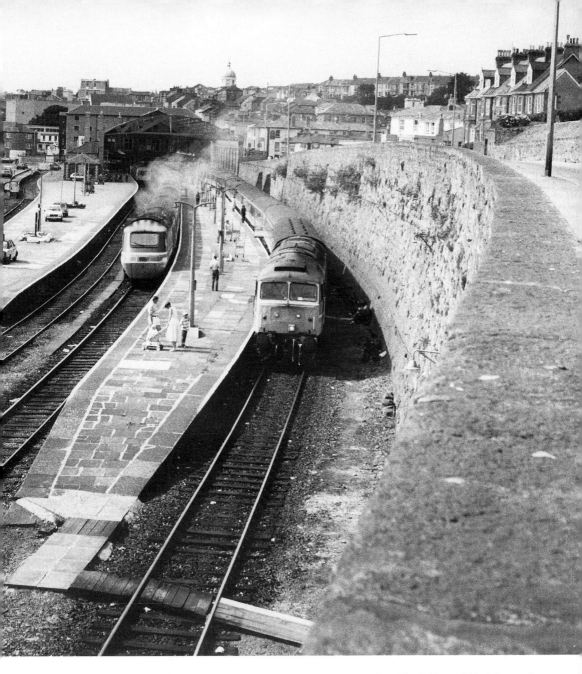

...nding at Platform 1 of Penzance station on 6 August 1989 is an unidentified Class 47 in Network ...uth East livery waiting to depart with the 12.50 p.m. to Paddington. The photograph was taken from ...'Wall' where countless pictures were taken in the days of steam. Ready to go at Platform 2 is a Type ...(HST), also to Paddington.

...posite, bottom: Class 47 No. 47766 *Resolute*, coupled to two other Class 47s, has paused at Par station ...1 September 1999. It had entered service at Toton depot some thirty-five years earlier (as D1621). ...March 1974, it became No. 47040 and, while allocated to Haymarket, it was renumbered again to ...come 47642. It was given the name *Resolute* at Crewe in August 1992 and retained the name through ...another renumbering. It was stored as unserviceable in April 2000.

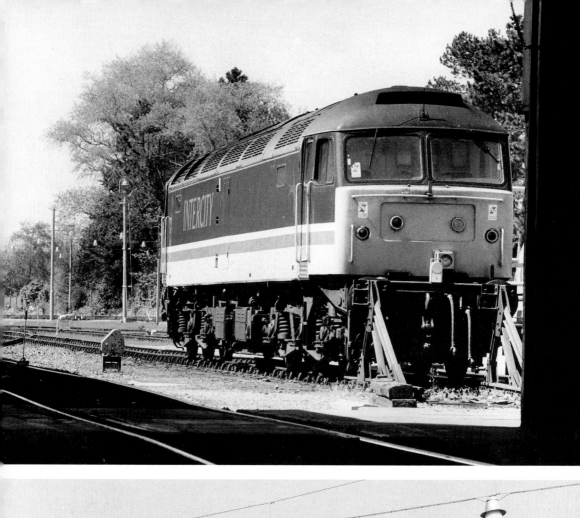

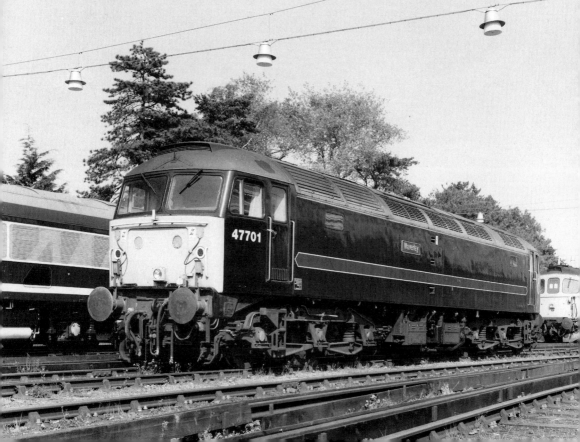

e 4 diesels ranged far and wide in
vice. Here, D1604 is seen at
Margaret's shed in Edinburgh in
e 1965. D1604 had entered traffic at
ansea Landore in the previous July
l, at the time of this photograph, was
ardiff Canton engine. D1604 (later as
. 47476) had a long career in service,
ing almost forty years.

, D1602, one of the Brush Type 4s
t at BR Crewe, came to traffic on
ly 1964 at Landore and, over the
t eight years, was reallocated several
es within the Western Region. Here
seen almost new, probably at the
mer GWR platforms at Salisbury,
rtly after entering service. D1602
renumbered (as 47474) in February
4 and was transferred to Bescot.
er the years, it underwent many
nges of allocation (Kingmoor, Crewe,
sley, Old Oak Common) before it was
igned to the Parcels pool in December
0. Stored as unserviceable in April
0, it was eventually scrapped in 2005.
orge Harrison/D.J.Hucknall Collection)

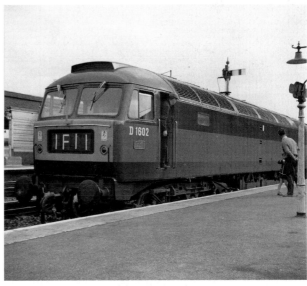

posite, top: The 'Swallow' livery was the final variation on the InterCity livery and was introduced
1989. It was a striking combination of colours and complimented the locomotives to which it was
lied. Here, at Bournemouth depot on 2 May 1997, an unidentified Class 47 awaits its next duty.
urnemouth, Poole and Southampton were served by InterCity's Cross Country division that linked
North-East to the South-West.

posite, bottom: Class 47 No. 47701 is seen at an open day at Bournemouth Traction and Rolling Stock
intenance Depot. At the time, the locomotive was in the livery of the now-defunct train-operating
npany Fragonset Railways Ltd. As No. D1932, the locomotive entered traffic at Bath Road shed
A). In May 1974, as a Leicester engine, it became No. 47493. In June 1977, it was transferred to
ymarket (HA) and underwent another change of identity, receiving the name *St Andrew* and the
nber 47701. In October 1987, it began to work from Eastfield depot and, after three years, it returned
th to Network South East. It acquired the name *Waverley* in May 1997.

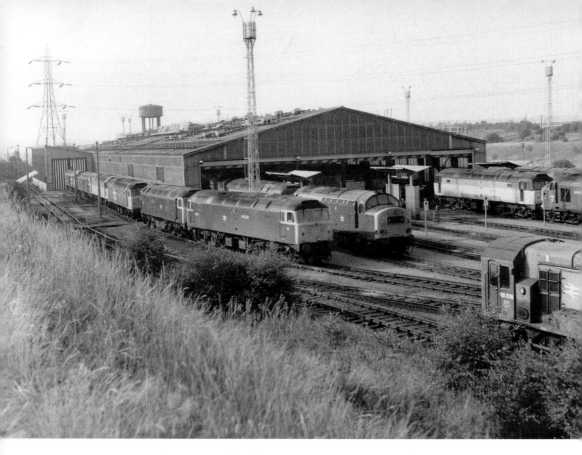

A view from the east of Tinsley Traction Maintenance Depot taken in August 1991, shows predomina[...] Class 47s although a couple of Class 37s are also present. Tinsley TMD adjoined Tinsley Marshall[...] Yard and came into use in the summer of 1965. It was the principal depot for a wide area to the no[...] west of the Eastern Region. In 1965 its allocation included thirty-three Brush Type 4s, thirty-six Eng[...] Electric Type 3s and thirty-two 350hp diesel shunters.

Opposite, top: Class 47/7 No. 47712 *Lady Diana Spencer* waits at Platform 4 of Queen Street stat[...] Glasgow, with the 12.30 p.m. push-pull service to Edinburgh Waverley. Initially entering servic[...] D1948 on the London Midland Western lines, the Type 4 became No. 47712 in November 1979. It [...] named at Queen Street station in April 1991 by Sir Peter Parker. *(W.A.C. Smith)*

Opposite, bottom: Class 47/7 No. 47702 *Saint Cuthbert* entered service in the Nottingham division in [...] 1966 as No. D1947. In December 1978 (then as No. 47504), it was transferred to Haymarket shed [...] worked the Glasgow–Edinburgh push-pull service. It was moved south again in December 1990 [...] was attached to the Network South East West of England service in October 1991, working there u[...] August 1993.

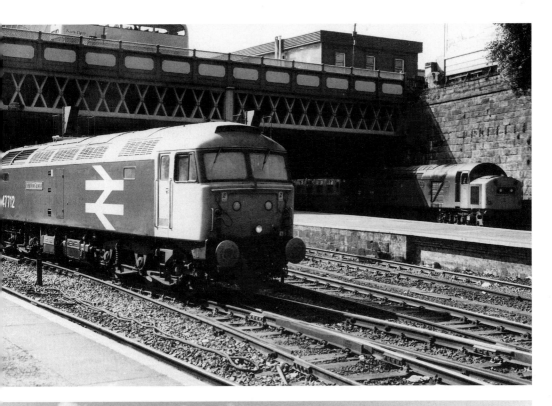

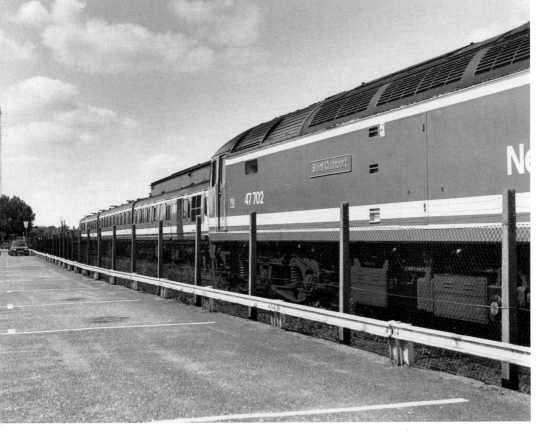

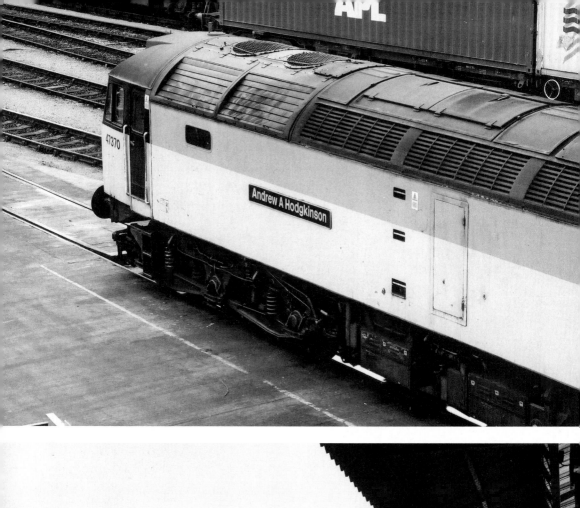

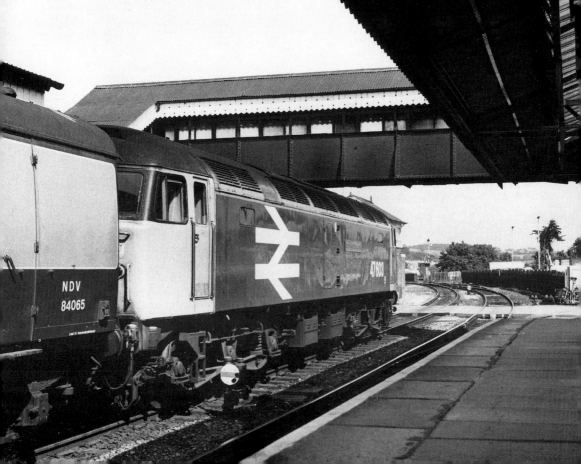

A view looking towards Poole station, with a background dominated by the striking architecture of Barclays International building, Class 47 No. 47471 *Norman Tunna G.C.* and its train stand in the sidings west of the station. Allocated to Crewe Diesel Depot at the time, No. 47471 would probably have been working the afternoon Poole–Manchester cross-country train.

Opposite, top: Class 47 No. 47370 *Andrew A Hodgkinson*, seen at the Freightliner depot at Southampton 2001, was named at Crewe Diesel TMD on 26 November 1996. There is a touching story attached the name. Andrew Hodgkinson was a disabled Hampshire man who died in 1996. He had asked Freightliner to name a locomotive after him because of the great pleasure he obtained from his model train set. No. 47370 entered traffic in July 1965 as No. D1889 at Tinsley depot. It was renumbered as No. 47370 in January 1974. It is shown here in trainload grey. In February 2003, it was placed in the Freightliner holding pod and it appears not to have been scrapped.

Opposite, bottom: No. 47603 *County of Somerset* is halted at Truro station on 11 August 1990 with an Up parcels train. The striking BR 'Large Logo' livery is once again apparent. When new, in October 1965, it was assigned to Cardiff Canton depot. It underwent a change of identity in March 1974 and became No. 47267. It acquired the number 47603 in February 1983 and worked from Bath Road shed, Bristol. It was allocated to the Parcels pool in October 1993. Eventually, after thirty-nine years of service, it was scrapped in August 2004.

With about a mile to go, an unidentified Class 47 and its train approach the sharp curve leading to Poole station. On the horizon, above the locomotive, the cranes on Poole Quay can be seen.

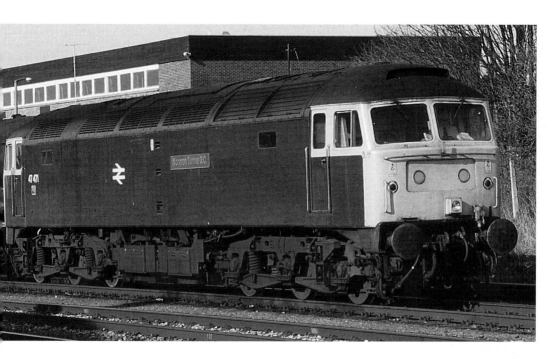

ss 47 No. 47471 *Norman Tunna G.C.* stands in the Up sidings at Poole with its cross-country train. e locomotive was named at Liverpool Lime Street station on 15 November 1982. It was a Crewe ;ine from May 1979 until September 1985. Norman Tunna was a shunter with the GWR. During an raid on Morpeth Dock in Birkenhead, Mr Tunna found two burning incendiary bombs in a wagon itaining two 250lb bombs. With little thought for his own safety, Mr Tunna put out the burning endiaries and removed them from the wagon.

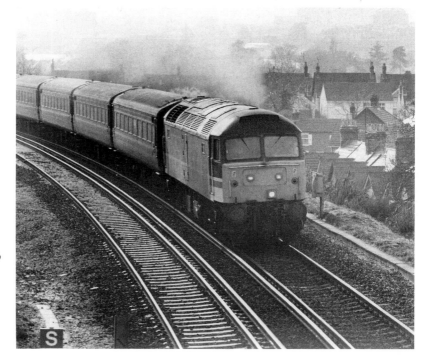

h a little further to before the 1 in 60 of kstone bank begins to e, Class 47 No. 47805 ed with long-range l tanks) approaches kstone station on March 1991 with the le–Manchester train.

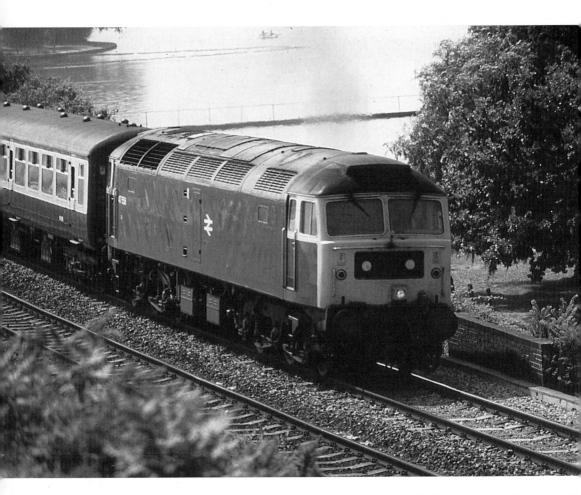

With a background of Poole Park boating lake, Class 47 No. 47556, as the haze from its exhaust confir
starts to climb Parkstone bank in the summer of 1985. Although the gradient eases at Parkstone,
line reverts again to 1 in 60 through the steep cuttings towards Branksome. No. 47556 was buil
Crewe and entered service in May 1964 at Cardiff. It carried the BR standard blue livery (seen h
from February 1981 until March 1990.

6

The 'Warship' Class/
BR Class 42/43

In February 1957, an order for thirty diesel-hydraulic locomotives (Nos D803–832) was placed with Swindon Works. The previous year, three trial units (D800–02) had been built based on the German Kraus-Maffei Class V200. Diesel hydraulic transmission had been selected because, particularly in the 2,000hp range, it had a marked advantage over diesel-electrics of a higher power/weight ratio. For example, the D800 Class had an output of 2,200hp (1,620kW) arranged on four axles and it weighed 78 tons. The corresponding Type 4, for example, (the English Electric 1Co-Co1) had eight axles and weighed 133 tons. A further thirty-three units (Nos D833–D865) were ordered from the North British Locomotive Co.

D800 entered service in August 1958 and began work on Paddington–Bristol and Paddington–Penzance services. After a while, problems began to emerge. A major cause of complaint from the crews was of poor riding quality at high speed. Consequently, they tended not to be worked at speeds above 75mph.

By 1965, it was established that engine power of 2,700hp was required for heavy freight and passenger duties throughout British Railways. Within the permitted axle load on the main line of 19 tons, this meant that, irrespective of the type of transmission, six axles (C-C) were required.

Opposite: A miserable day at Penzance shed (30 March 1964) sees 'Warship' Class No. D807 *Care* (allocated to Laira at the time) standing in the yard. The locomotive had entered service on 24 June 1͡ No. D807's livery (BR green with a white stripe at waist height) was just visible and the locomot looked a little neglected. Nevertheless, *Caradoc* saw service for several years subsequently and ͘ withdrawn on 26 September 1972.

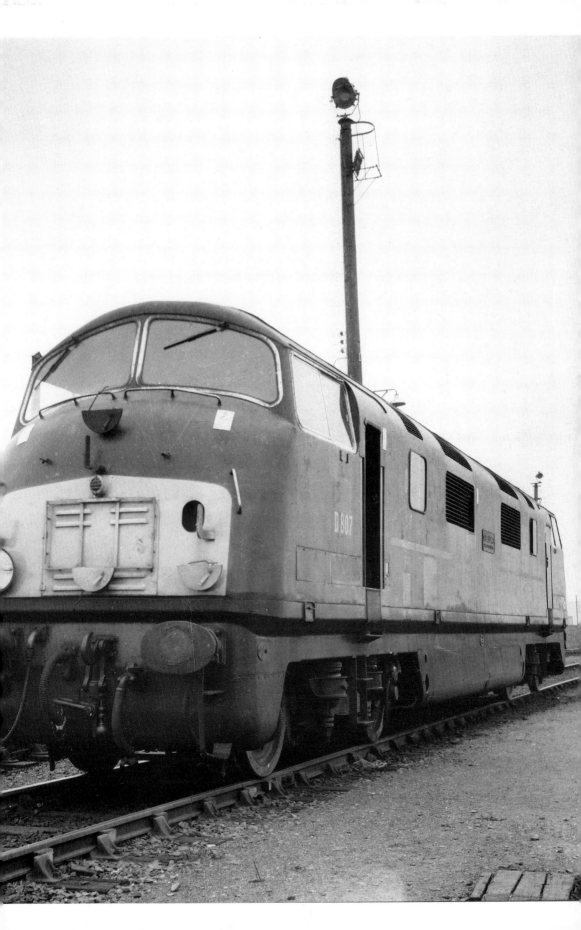

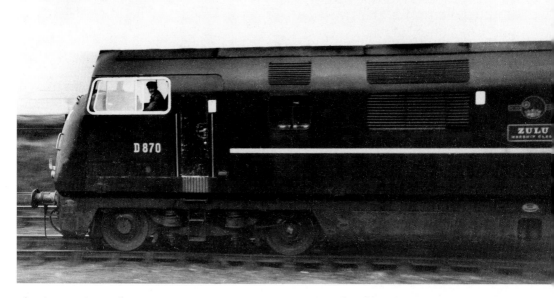

The driver of 'Warship' Class No. D870 *Zulu* acknowledges the photographer as his locomotive pas
with an Up train. Just behind the left-hand buffer of No. D870, the locomotive's shedplate showed t
it was allocated to 83D (Plymouth Laira). The photograph was taken on 30 March 1964 by the sidi
between Long Rock and Marazion.

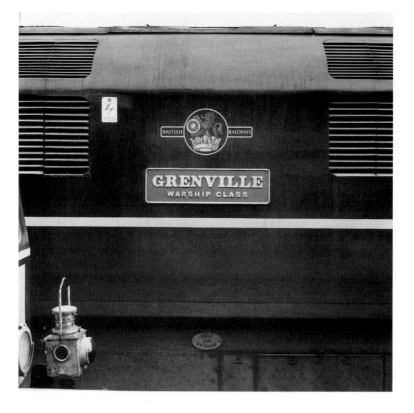

A detailed view of the
nameplate and livery
applied to Class 42
No. D820 *Grenville* at
Plymouth (North Road)
station on 13 July 1965
is shown here. As the
builder's plate confirms,
No. D820 entered service
in 1960 (actually 4 May
1960). It was withdrawn i
November 1972.

...nting signals at Long
...ck, a mile or so from
...nzance station, dominate
...s photograph of
...ss 43 No. D846 *Steadfast*.
...e locomotive had entered
...vice in April 1961 and
...s withdrawn ten years
...r.

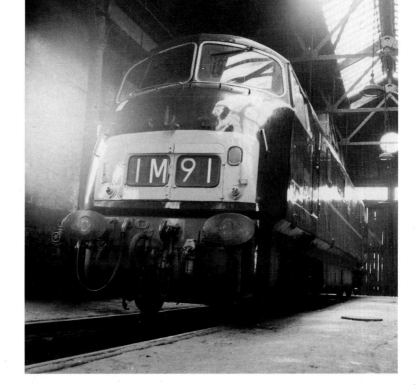

...med after the frigate,
...ss 43 No. D841 *Roebuck*
...ams as it stands in the
...gle-track repair shop
...m locomotive shed at
...g Rock on 11 July 1965.
... D841 entered service
...December 1960 and was
...hdrawn in October 1971.

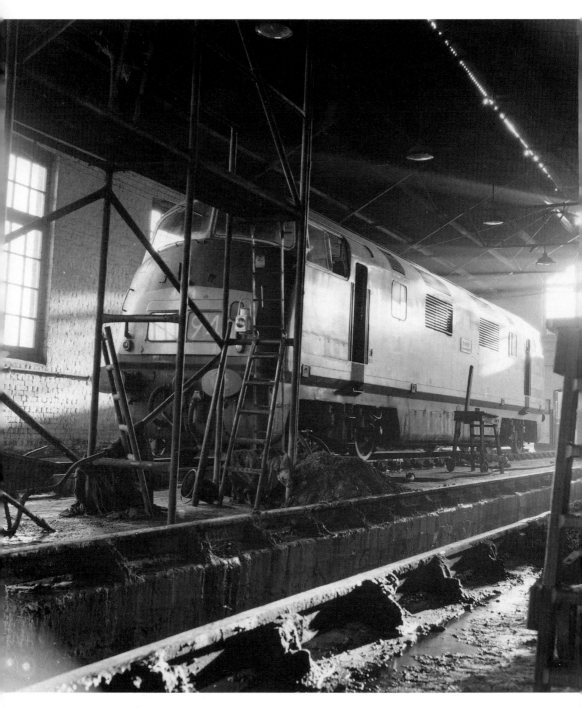

The rapid dieselisation of Britain's railways meant that many designs were introduced from a ra[n]
of manufacturers. Although there were unsatisfactory products with design shortcomings, [a]
important contributory factor to unreliability was the fact that, in many cases, diesel locomoti[ves]
were stabled and serviced in close proximity to steam locomotives and conditions inside a work[ing]
steam shed were quite unsuited to the requirements of diesel locomotives. Excellently illustrat[ing]
this point, Class 43, No. D870 *Zulu* can be seen in very doubtful conditions at Salisbury shed in 19[]
(George Harrison/D.J. Hucknall Collection)

he rain at Truro station on
uly 1965, 'Warship' Class
. D803 *Albion* pauses with a
wn Manchester–Penzance train.
lt at Swindon, No. D803 entered
vice in March 1959. It was
hdrawn in January 1972.

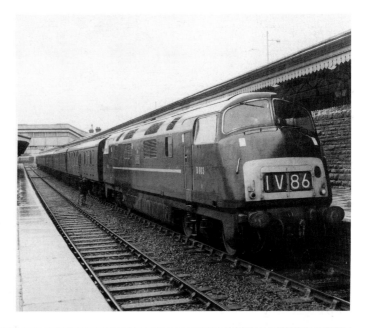

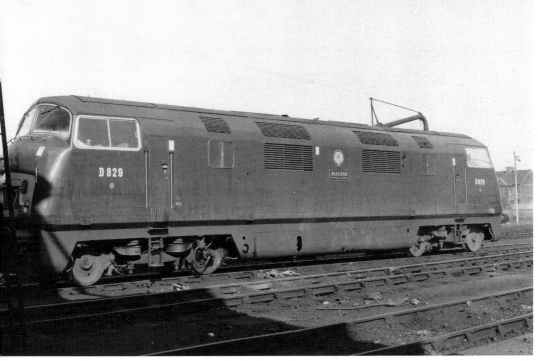

Monday 6 September 1964, the Western Region introduced a 'Warship' diesel-hauled semi-fast
vice between Waterloo and Exeter St David's. Apart from the 'Atlantic Coast Express', average
es from Waterloo to Exeter Central were, in theory, 2 minutes less and, to St David's, 5 minutes
. In the opposite direction, the gains were 5 and 15 minutes respectively. At the beginning of June
4, 'Warship' Class No. D829 *Magpie* arrived at Salisbury shed for crew training. This involved three
irn trips to Basingstoke with a train of thirteen condemned coaches. The locomotive is seen at
sbury shed during this period. On 8 June, it was replaced by D819 *Goliath*.
orge Harrison/D.J. Hucknall Collection)

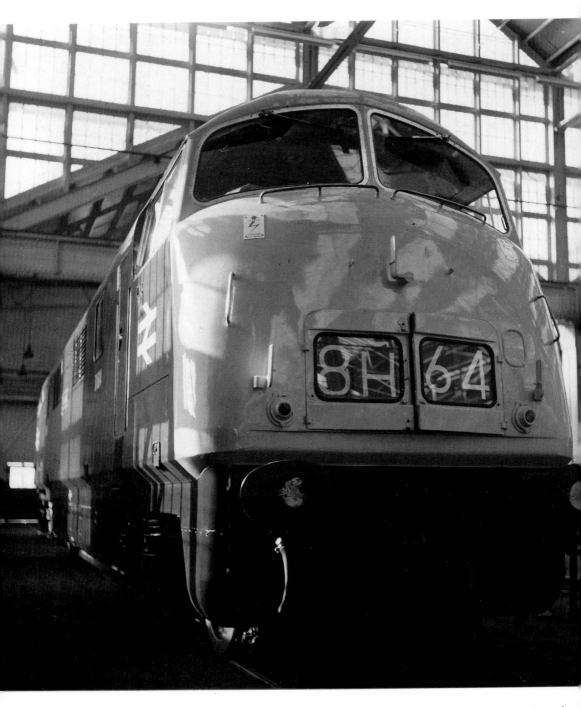

'Warship' Type 4 No. D864 *Zambesi* is seen in the main assembly bay at Swindon Works after a hea
repair in November 1966. The locomotive was painted in the then-new 'Rail Blue'. No. D864 w
introduced to service in May 1962 and was withdrawn on 27 March 1971. (*George Harrison/D.J. Huck
Collection*)

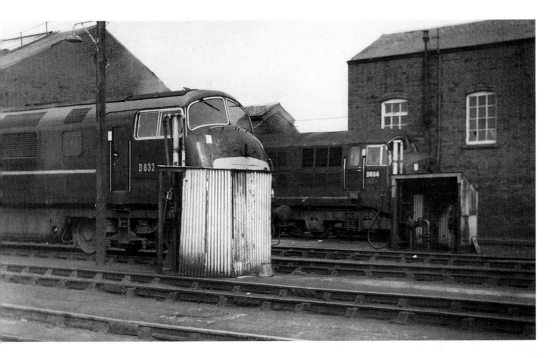

diesel locomotive refuelling facilities outside the old steam shed at Penzance are seen in July 1963.
he yard at the time were 'Warship' Class No. D832 *Onslaught* and No. D604 *Cossack*. *Cossack* was one
 group of five 'Warship' Class locomotives ordered by BTC from the North British Locomotive Co.,
ough the Western Region, apparently, did not want them. They were considerably heavier (117t)
n the Western Region's preferred product (78t) – for example No. D832 – and it seems that BTC
nted to compare the class's performance with that of the EE Type 4.

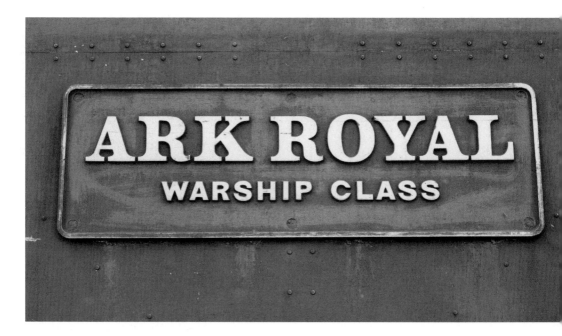

The nameplate of another BTC-ordered 'Warship' Class locomotive is shown here. No. D601 enter
service with the Western Region on 28 March 1958 and was withdrawn on 30 December 1967.

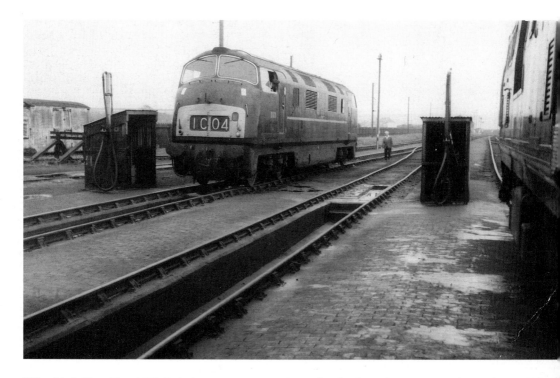

'Warship' Class No. D870 *Zulu* is seen reversing from the shed yard at Long Rock in July 1963. D87
was in service for less than ten years. Having entered service in October 1961, it was withdrawn in
August 1971.

7

'Western' Class 52
Diesel Hydraulics

Under BR's modernisation plan, the Western Region employed a policy of using diesel-hydraulic traction. The perceived advantage over diesel-electric was that a lighter locomotive giving a better power-to-weight ratio would result. In 1961, BR placed an order for seventy-four 2,700hp (2,000kW) diesel-hydraulic locomotives – the 'Western' Class. The first was delivered from Swindon Works in December 1961.

Unfortunately, diesel-hydraulic technology was a radical departure in Britain and although successfully used in Germany, it was considered 'politically unacceptable' to order locomotives from German companies so soon after the war. In the end, the diesel-hydraulic experiment failed on low fleet numbers (358 hydraulics compared to 2,315 locomotives with diesel-electric transmission), poor maintenance conditions and a design fault. This fault involved a mis-match between the Maybach engines and the Voith hydraulic transmission. It is said that the top gear ratio in the transmission was too high for the torque characteristics of the engine and a single locomotive could struggle to reach its claimed top speed in the absence of a down grade and this was particularly marked when the locomotive was due for overhaul. Factors such as this and the 'casualty rate' (miles/defect), which was significantly higher for the 'Westerns', for example, compared to the Brush Type 4s, meant that the 'Westerns' could not continue in top-line service.

...

Opposite, top: This photograph, taken at Swindon Works, shows four 'Western' Class 52s undergo overhaul. Identifiable is No. D1055 *Western Advocate*, a locomotive built at Crewe Works in March 19 Its first shed was Cardiff Canton and its last shed was Laira, Plymouth. It was scrapped in June 1 at BREL, Swindon. *(George Harrison/D.J. Hucknall Collection)*

Opposite, bottom: Class 52 No. D1001 *Western Pathfinder* has attracted the attention of a number bystanders, and its train is also reasonably busy as it stands at the Down platform at Paignton stati Protecting the Up platform is a well-cared-for ex-GWR awning and the general impression is o useful, well-run station. *(D.E. Canning)*

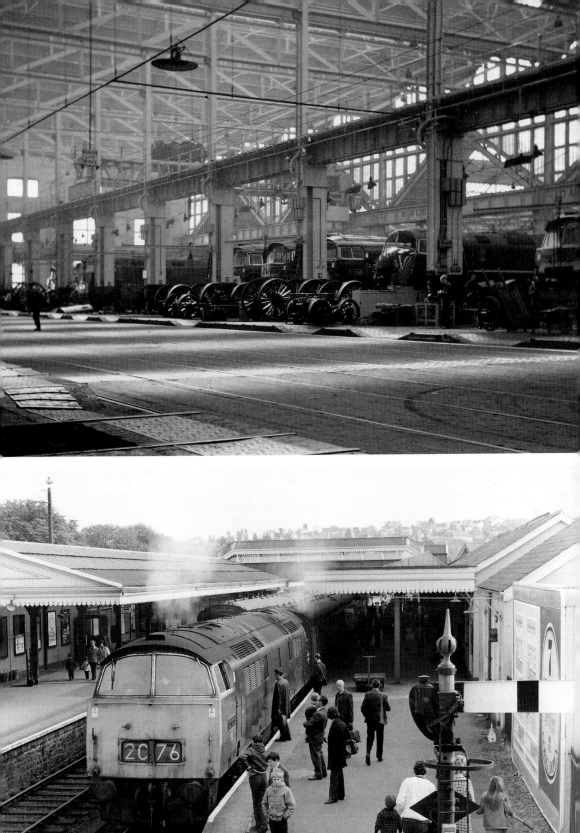

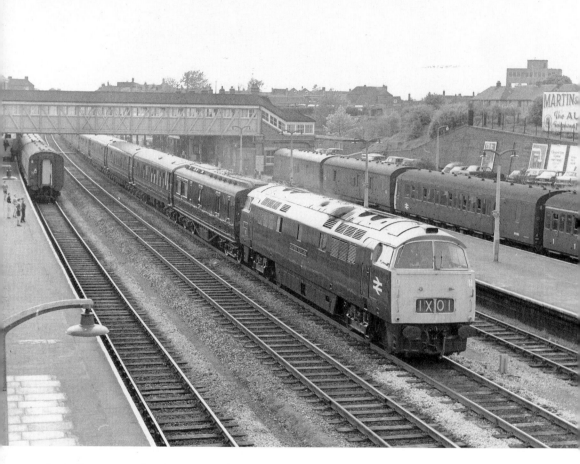

As befits a train hauling 1XO1 (a Royal Train), Class 52 No. D1023 *Western Fusilier* is super
clean and polished as it passes through Newbury station on the Up Westbury line. Royal Tra
ran under special double-block signalling arrangements whereby the section ahead had to be cl
before it could be accepted from the box in the rear. No. D1023 had been built at Swindon and w
completed in September 1963. Initially, it was a Cardiff Canton engine but was transferred to Swans
Landore in February 1965. It returned to Canton briefly in March 1966 and was then reallocated
Laira. Withdrawn in February 1977, the locomotive is now part of the National Railway Collecti
(*D.E. Canning*)

Opposite, top: A further view of Class 52 No. D1001 *Western Pathfinder* (see page 81) at Paignton stati
taken from the footbridge at the northern (Torquay) end of the station. (*D.E. Canning*)

Opposite, bottom: On 20 April 1975, Cranmore station on the East Somerset Railway was opened
HRH Prince Bernhard of the Netherlands (then President of the WWF). He was 'conveyed' by a tra
hauled by Class 52 No. D1072 *Western Glory*. Here, D1072 is watched by a number of spectators on
Down Westbury line as it hauls the 'East Somerset Railway Special'. (*D.E. Canning*)

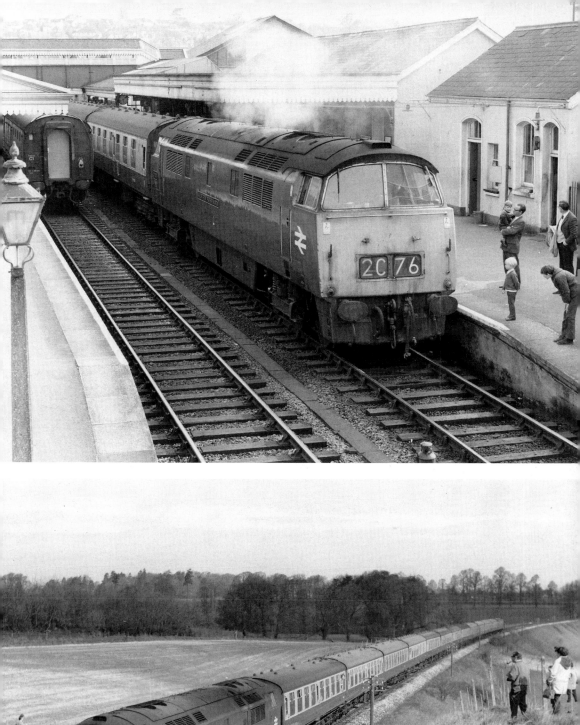

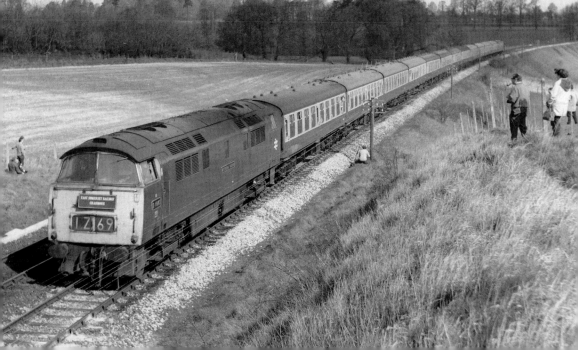

Class 52 No. D1049 *Western Monarch* stands outside the repair shop at Penzance shed on 30 March 1964. Completed at Crewe in mid-December 1962, a combination of harsh detergent and mechanical cleaning had, in about fifteen months, left D1049's maroon livery dull and, in places, scraped away to the undercoat. Nevertheless, the locomotive completed almost fourteen years of service and, on withdrawal, had covered 1.3 million miles.

'Western' Class No. D1053 *Western Patriarch* stands at the platform end at Plymouth North Road station on 13 July 1965. No. D1053 had been built at Crewe in February 1963 and was withdrawn in November 1976. The absence of a number plate on the locomotive was due to the fact that they were only fixed to the left-hand side of the locomotive when it was viewed from the side.

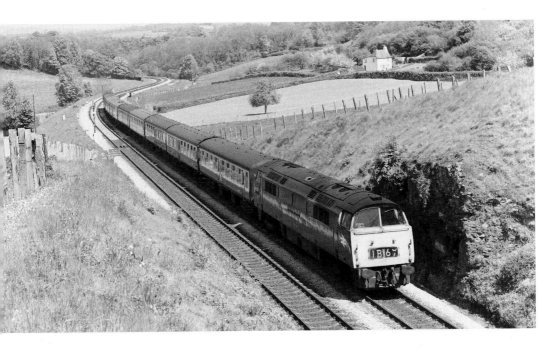

'estern' Class No. D1054 *Western Governor*, together with nine bogies, is seen on the Down Westbury
of the Berks and Hants Extension. *(D.E. Canning)*

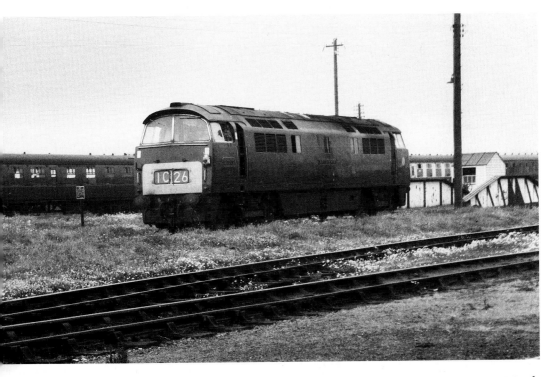

'estern' Class No. D1012 *Western Firebrand* is seen by the turntable at Penzance depot on 30 March
64. The reporting number (1C26) indicated that the Class 52 would later be taking either an express
ssenger train or a postal/parcels train to Paddington.

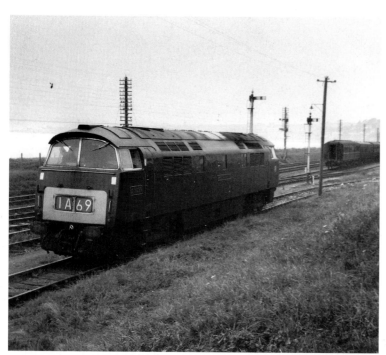

Class 53 No. D1039, havin
left Penzance depot, head
towards Marazion before
reversing and proceeding
to Penzance station prior t
heading train 1A69.

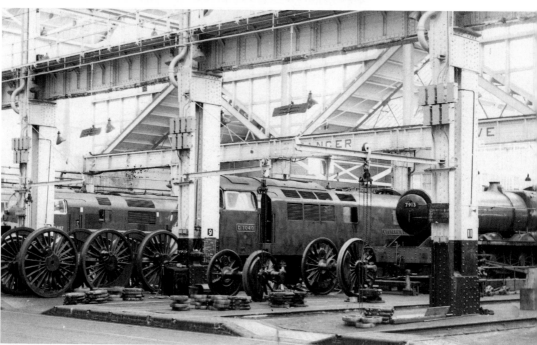

The period of transition from steam to diesel at Swindon Works is shown here. 'Modified Hall' Cla
No. 7913 *Little Wyrley Hall* is seen under repair, together with Type 4 'Warship' Class No. D807 *Cara*
and Class 52 No. D1040 *Western Queen*. As far as main line locomotives were concerned, the pl
for diesel maintenance was based on the concept of carrying out maintenance such as engine a
transmission changes at motive power depots, the locomotives themselves only entering works
tasks involving dismantling their structure, piping or wiring. This photograph was probably taken
June 1963 when No. 7913 was in the works for general overhaul. *(H.G. Usmar/D.J. Hucknall Collectio*

8

**InterCity 125/
BR Class 43 HST**

InterCity 125 was a brand name for British Rail's High Speed Train (HST) fleet. The InterCity 125 was made up of two power cars, each at the ends of a fixed formation of coaches, capable of 125mph in regular service.

The background to the InterCity 125 units and, certainly, the demonstration of the use of high-speed diesel-electric multiple units, can be ascribed to the Blue Pullman luxury trains that were used from 1960 to 1973 by British Railways. Five sets of Blue Pullmans were built by Metro-Cammell in Birmingham. They consisted of Motor Cars (BR Class 251) plus kitchen and parlour cars (BR Class 261). The last sets were withdrawn in May 1973. Further impetus to the development of the 125s came from work at British Railways' research division at Derby. To complement the APT-E (tilting train) work, it was decided in 1970 to build two lightweight 125mph Bo-Bo locomotives to top-and-tail a rake of 23m-long Mk3 coaches. After trials, the concept was verified and BR decided to build twenty-seven production HSTs to transform the Paddington to Bristol and South Wales services. The first production car, No. 43002, was delivered in 1975.

Opposite, top: A pair of InterCity 125s and their trains stand at Platforms 1 and 2 at King's Cross static At Platform 4, a conventional Class 47-hauled train awaits departure. Until the introduction of t HST, the maximum speed of British trains was limited to 100mph (160kph). The HST allowed a 25 p cent increase in service speeds on the main lines on which they operated.

Opposite, bottom: The original InterCity 125 livery was blue and grey with a yellow front panel improve the unit's visibility. To a certain extent this is shown in this view taken at King's Cross.

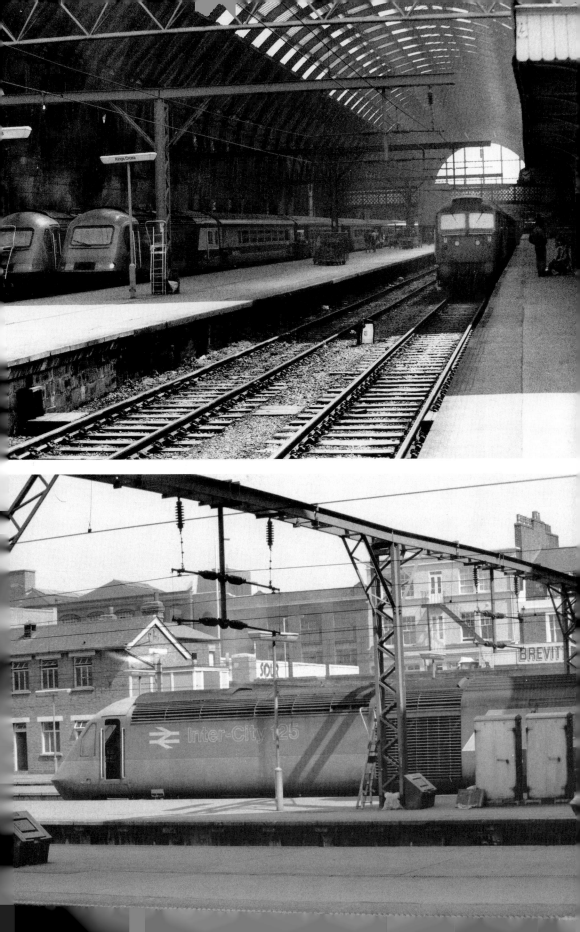

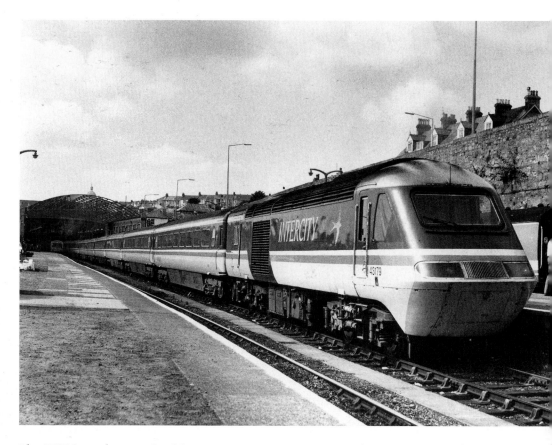

The HST brought considerable improvements in service on the railways. On the Western Regi
the InterCity 125s were introduced initially for all services between Paddington and Bristol/So
Wales. The use of the Class 43 (HST) was widened to include most of the day-time services to De
and Cornwall and brought about much-needed improvements. Here, unit No. 43179, in the sup
InterCity livery, is seen at the head of the 11.45 a.m. to Paddington at Penzance station on 6 Aug
1989.

Opposite, top: Coming off the Carvedras viaduct and passing Truro's GWR Type 1A signal-box of 1
a Paddington–Penzance enters the station on Saturday 11 August 1990. Certainly on the Plymou
Penzance section of the line, the increased speed and rapid acceleration/deceleration of the H
brought considerable improvements in service.

Opposite, bottom: A Great Western train from the direction of Malvern and headed by Class 43 (H
No. 43037, comes off the branch line and enters the north end of Worcester Shrub Hill station on
Up main line on 28 May 1997.

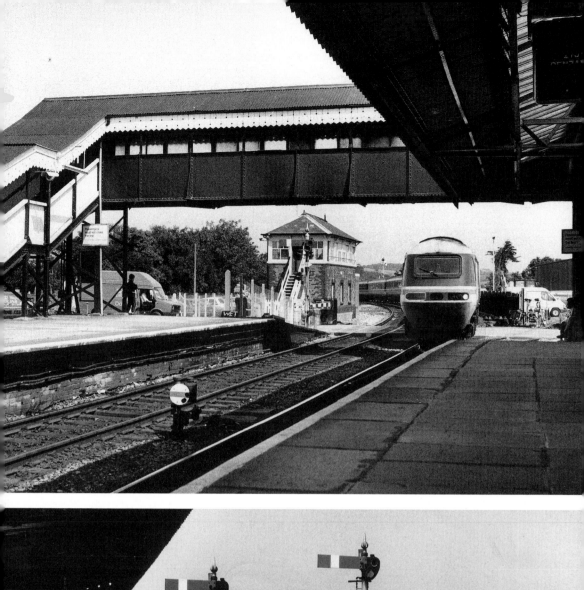

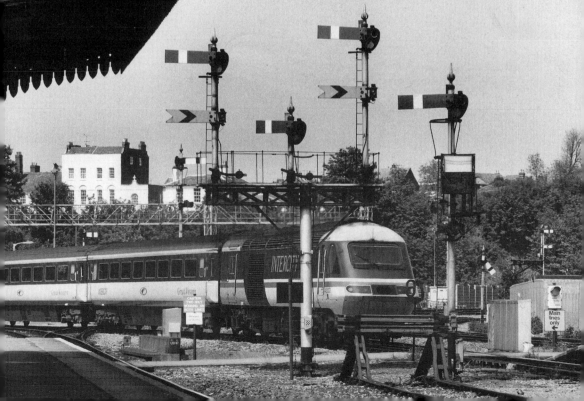

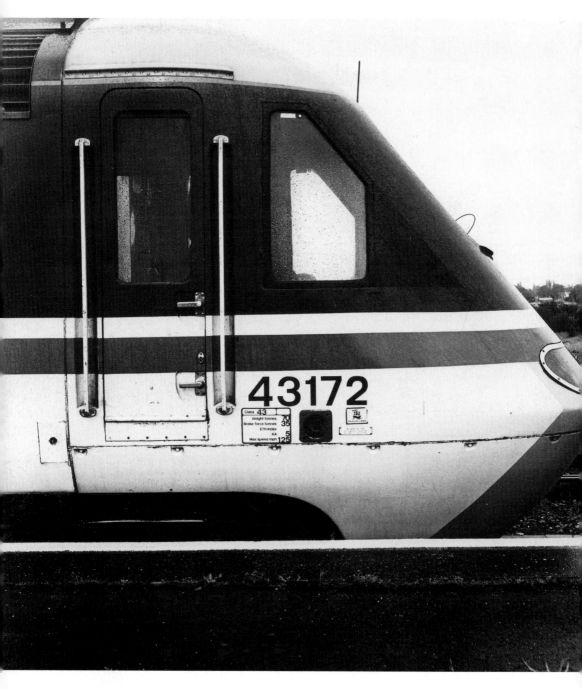

Light rain falls on Class 43 (HST) No. 43172 as it stands at Platform 5 at Didcot Parkway station. Be
the number, the depot name of the unit (in this case Plymouth Laira) is shown. No. 43172 remair
Laira engine.

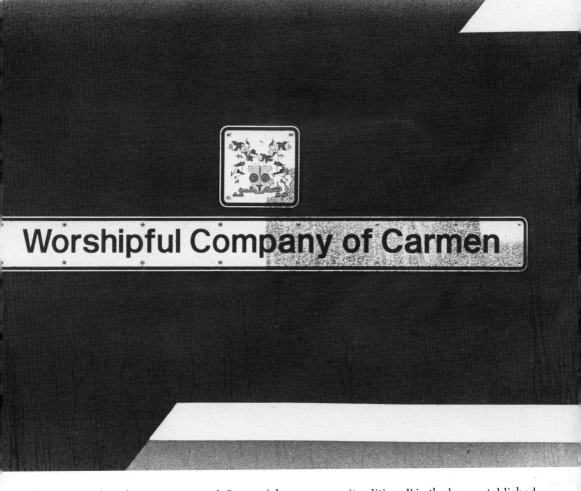

ny of the Class 43 (HST) units are named. Some of the names are 'traditional' in the long-established way tradition (schools, regiments, etc.). Seen here at Didcot station on 30 May 1993 are the rain-ttered nameplate and coat-of-arms for No. 43132 *Worshipful Company of Carmen*, a St Philips Marsh t.

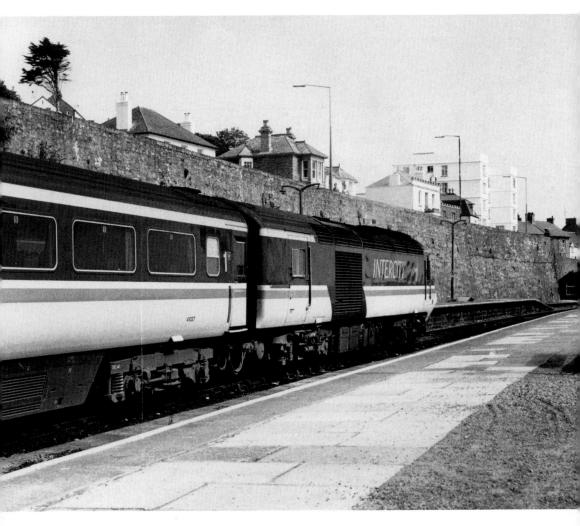

A further view of the 11.45 to Paddington, Class 43 (HST) No. 43179 and its train stand at Penza
station (326.5 miles from Paddington) on 6 August 1989. No. 43179 is maintained at Plymouth an
named *Pride of Laira*.

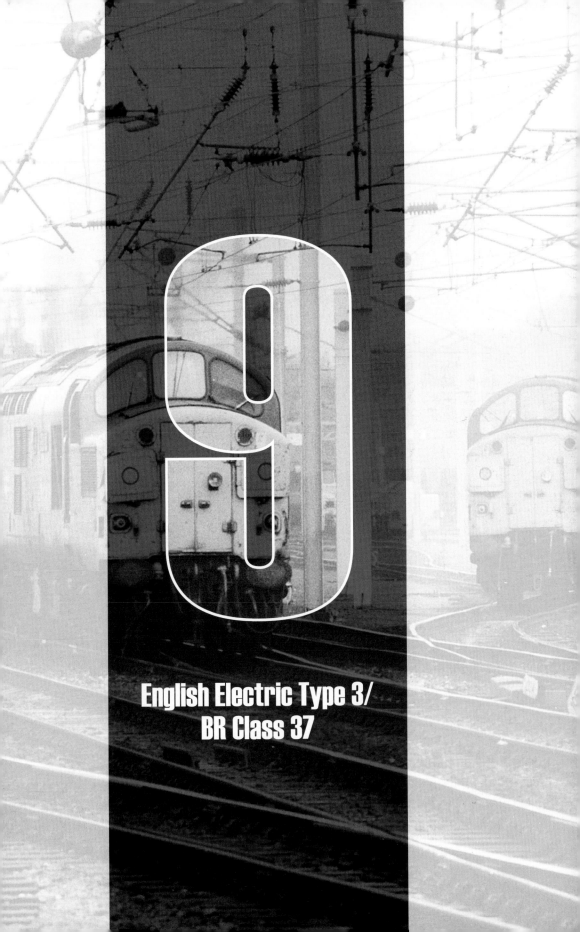

9

English Electric Type 3/
BR Class 37

When the British Transport Commission was looking for companies to build a Type 3 diesel, English Electric was able to offer a design that was already performing well in service with East African Railways.

English Electric was duly awarded a contract in 1959 for forty-two locomotives based on the EAR design but with a 1,750hp engine rather than the 2,024hp unit that was used in Africa. Another influencing factor may have been the fact that many of the internal components on the new class were based on the EE Type 4 which had been introduced to British Railways in 1958.

During the period 1960 to 1965, some 309 units (Nos D6700–6999 and D6600–08) were built, either by English Electric at Vulcan Foundry or, because the former was working at full capacity, sub-contracted to Robert Stephenson and Hawthorns at Darlington.

In the 1980s, many of the Class 37s were extensively refurbished at BREL in Crewe – the type of modification being indicated in the class number. For example, the 37/3 sub-class had been re-bogied and its members had their fuel capacity doubled. The 37/5 series were refurbished, re-wired and the English Electric generator replaced with a Brush alternator.

The class is very well represented (thirty-two locomotives) on preserved railways and many are in the hands of devoted enthusiast groups.

Opposite, top: Southampton is now probably the UK's main vehicle-handling port (668,000 units w handled in 2006). The first Class 37 to enter the docks for car transporter traffic was No. 37211 in 19 Originally built as English Electric Type 3 No. D6911, the engine is seen here close to the Canute R Crossing where it entered the Eastern Docks. *(D.J. Hucknall Collection)*

Opposite, bottom: English Electric Type 3 No. D6763, in BR green, is seen heading an Up freight thro York station on 22 July 1964. D6763 was delivered in November 1962 and allocated to Thornaby. It renumbered 37063 in February 1974. It was eventually withdrawn in January 1999 after thirty-se years of service.

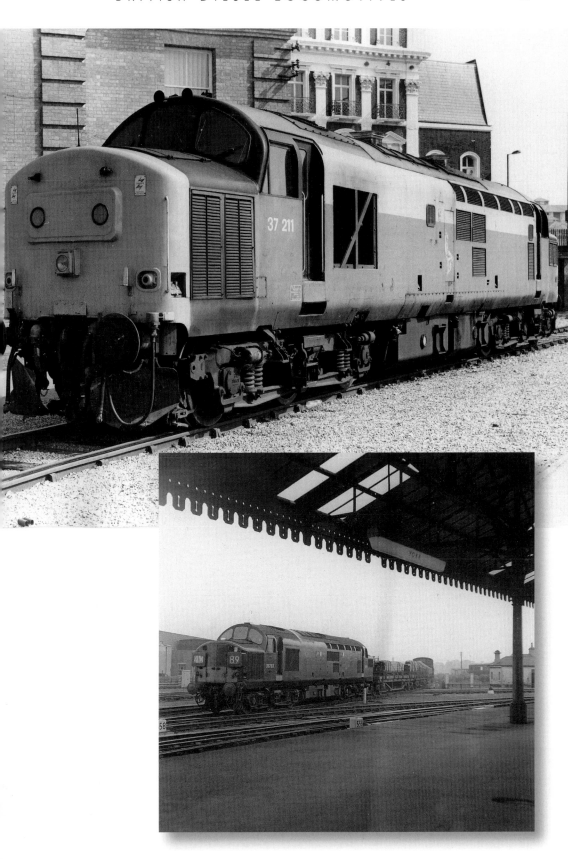

English Electric Type 3 No. D6800 is seen passing the level crossing at Beckingham in Lincolnshire, on the Gainsborough–Doncaster line, in August 1964. Delivered from Vulcan Foundry in December 1962, it was first allocated to Darnall shed. It was renumbered as 37100 in February 1974. Officially withdrawn from stock in November 2005, it was, in 2006, re-registe with Network Rail as No. 97301.

Type 37s, Nos 37896 and 37897, are seen i the northern sidings in Didcot yard. Both are in two-tone grey livery with the blue-and-red Transrail logo. Formed in 1994, Transrail was a trainload freight operator in south-west England, the north-west an Scotland. It was one of the freight compar bought by Wisconsin Central which led to the formation of English, Welsh & Scottish Railway (EWS). The Type 37s shown here were originally Type 37/7 locomotives, a sub-class which resulted from the refurbishment and re-wiring of the origin Type 37s.

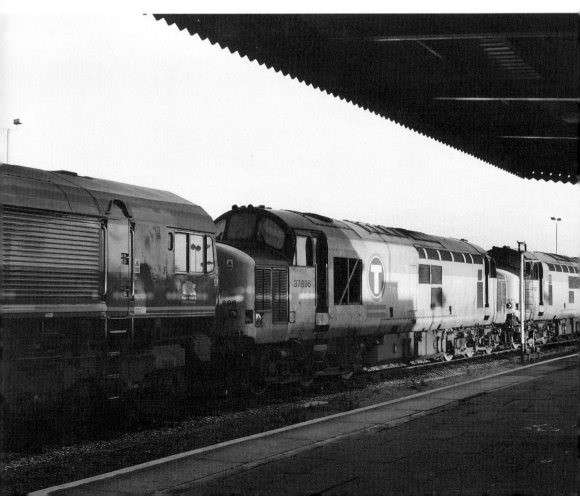

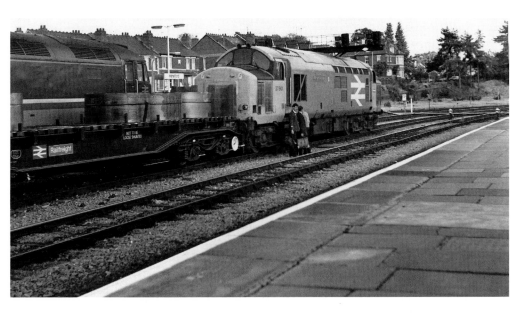

Class 37/9 No. 37901 *Mirrlees Pioneer* (originally D6836, then 37136) is seen at Hereford station on 30 August 1990, following a crew change. In 1986, four Class 37s (Nos 37150, 37148, 37249 and 37124) were used to test the Mirrlees MB27ST engine for the then-proposed Class 38. They were numbered 37901–4. Trials with two other type 37s fitted with Ruston engines were also carried out. Painted in Railfreight grey, all six were based in South Wales as part of British Rail's Heavy Metals Sector. No. 37901, together with 37905/6, is now preserved.

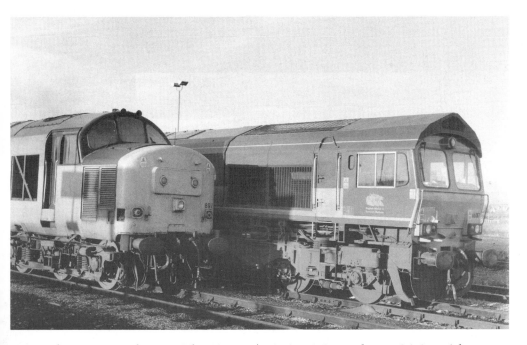

During the late 1990s, the use of the Class 37/9 declined due to the availability of the newer Class 66 locomotives and, by 1999, the Class 37/9 were in storage. In this view, taken at Didcot sidings, Class 37 No. 37897 and a successor, Class 66 No. 66017, are seen. No. 37897, as D6855, was initially allocated to Landore. It became No. 37155 in April 1974 and was further renumbered as 37897 in December 1986.

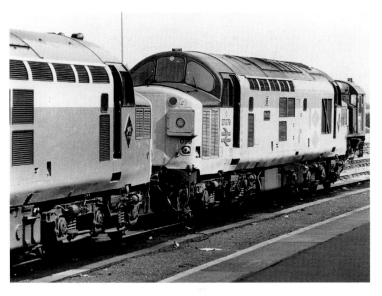

As No. D6779, English Elect
Class 3 entered service at H
Dairycoates in November
1962. In August 1964 it becai
a Thornaby engine. It was
subsequently re-bogied and
became No. 37357 in June 19
A further renumbering at th
end of March 1990 occurred
and the locomotive became
No. 37079. When seen at
Didcot on 25 August 1991, t
locomotive had been named
Medite and had the logo of t
Mediterranean Shipping Co
SA, above the nameplate. TI
name was removed in Janua
2000, and the locomotive w
cut up in August 2008 after
forty-six years in service.

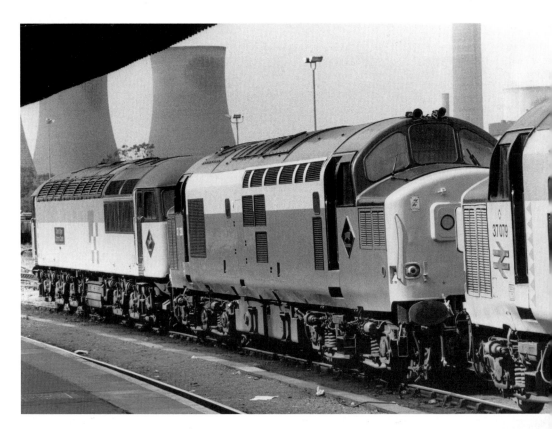

Class 37 No. 37233 stands in Didcot sidings on 25 August 1991 together with No. 37079 *Medite*
Type 56 *Ogmore Castle*. No. 37233 was carrying the depot plaque for Cardiff (a mountain goat!) w
Ogmore Castle carried a plaque showing a prancing white horse. The latter was carried by Westb
locomotives since the depot was relatively close to the Vale of White Horse.

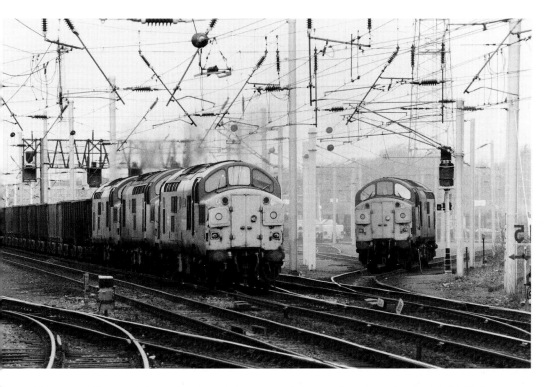

iew of Mossend Up yard from the site of the former Mossend station shows the 10.59 departure
Ravenscraig on the Up main line on 18 April 1990. Piloting the 10.59 is Class 37 No. 37097 with
; 37040 and 37088 attached to the train. *(D.J. Hucknall Collection)*

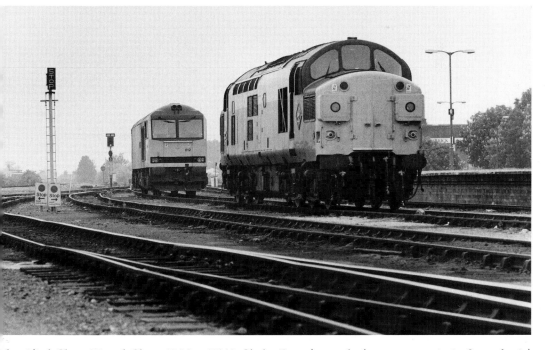

dentified Class 37 and Class 60 No. 60012 *Glyder Fawr* (named after a mountain in Snowdonia)
d in siding No. 3 of Didcot yard northern sidings on 26 May 1991.

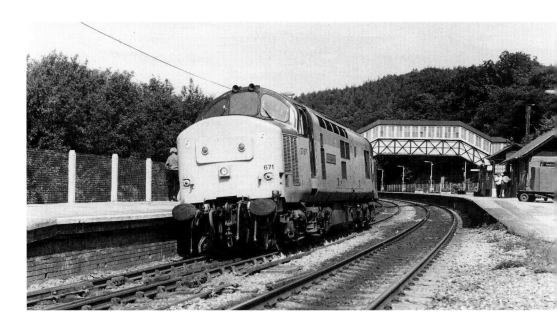

Appropriately named for duties in Cornwall, Class 37 No. 37671 *Tre Pol and Pen* stands at the platform at Bodmin Road on 9 August 1991. As No. D6947, the locomotive was delivered from Vu[l]can Foundry at the end of October 1964. It was renumbered as 37247 in April 1974 and named *Tre Pol [and] Pen* at Laira in July 1987. It carried that name until July 1999.

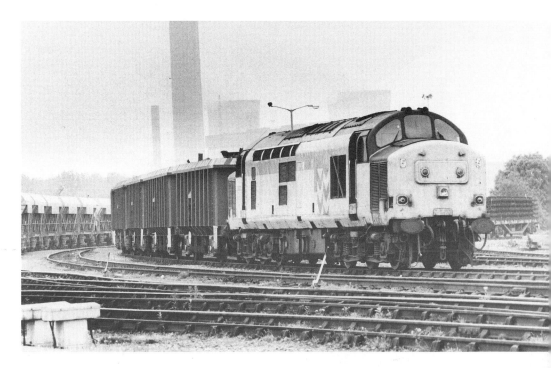

Class 37 No. 37889 (delivered from Vulcan Foundry in April 1964 as D6933) is seen in Didcot sid[ing] on 26 May 1991. The decal applied to the side of the locomotive indicates that it was assigned to [the] 'Metals' sub-division of TrainLoad freight. The locomotive acquired the number 37889 in Novem[ber] 1987.

10

Clayton Type 1 diesels
'Claytons'/BR Class 17

Regarded initially as the basis of the standard Type 1 for BR, they were failures because of the Paxman engines that powered most of them. The 'Claytons' were so named because the majority of the class (Nos D8500–87) were built by the Clayton Equipment Co. of Hatton, Derby (the remainder – D8588–D8616 – were built by Beyer-Peacock). Unusual among the early diesels, they had centre cabs with the engines, in lower bonnets, at each end. The result was a very pleasant-looking locomotive.

The engine problems (camshaft failures, crankcase fractures) were never satisfactorily resolved, and the first withdrawals began within three years of the last engine being delivered.

Of the 117 originally built, the majority worked in Scotland, either from Haymarket or Polmadie. In England, Nos D8588–91 worked from Thornaby, Nos D8592–D8603 were at Gateshead, Nos D8604–15 were at Tinsley and No. D8616 was at Barrow Hill.

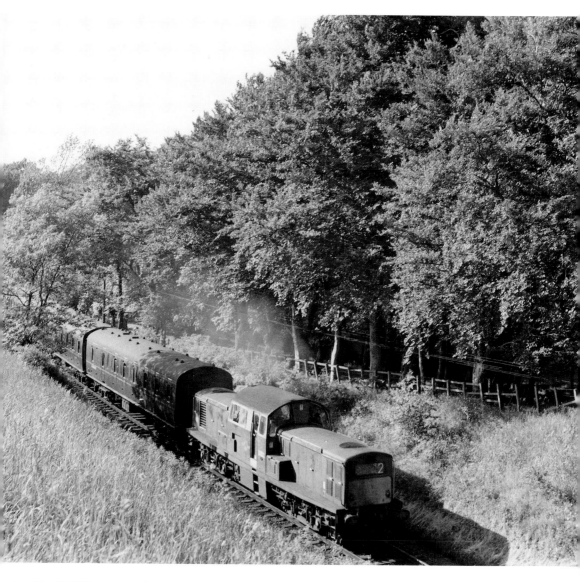

ayton No. D8532 restarts the 17.33 p.m. train from Glasgow St Enoch at Thorntonhall on 25 June
4. No. D8532 entered service in July 1963 and lasted a mere five-and-a-half years. It was scrapped
3REL, Glasgow, in June 1972. *(W.A.C. Smith)*

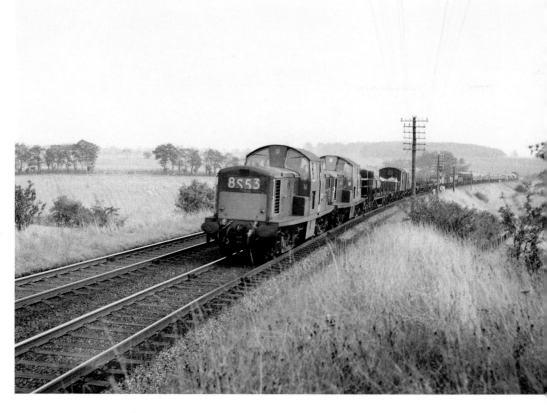

I would see some of the Claytons in pristine condition on the Sheffield (Midland) to Rotherham
on their way to the Scottish Region. Here, Nos D8532 and D8514 are seen, with a Down freigh
21 September 1963, near Braidwood on the West Coast Main Line. Of the pair, D8532 was delive
in July 1963 but withdrawn about five years later in December 1968. No. D8514 was also introdu
in July 1963 (and was one of the Claytons I admired when it was heading north). It was withdraw
October 1969. *(W.A.C. Smith)*

Opposite, top: Claytons, Nos D8538 (in blue livery) and D8558 (in green), cross Fauldhouse Moo.
the Benhar mineral branch with a coal train from Polkemmet Colliery to the Ravenscraig steelwo
Established in the 1950s with a substantial amount of government money, Ravenscraig produce
own iron in blast furnaces using ore shipped in at Hunterston and with coal from Polkemmet.
demise of Ravenscraig in the mid-1990s was seen as an economic and social disaster for Lanarks
(W.A.C. Smith)

Opposite, bottom: One of the 'problem-ridden' Clayton Type 1 diesels, No. D8574, is shown pas:
Portobello station with the 12.52 p.m. from Edinburgh Waverley to Hawick on 29 August 1964,
week before the closure of Portobello. To the right of the picture, Leith South Junction signal-box
be seen. *(W.A.C. Smith)*

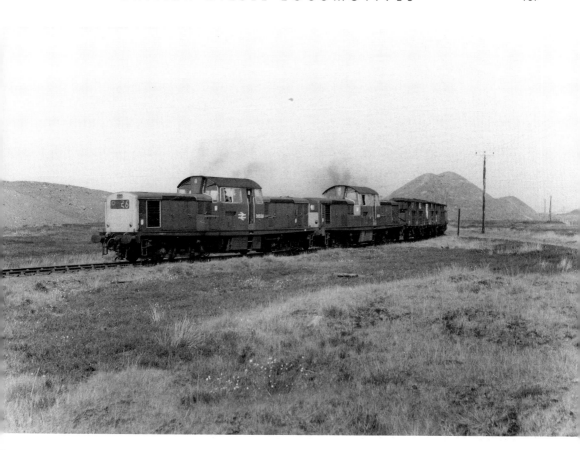

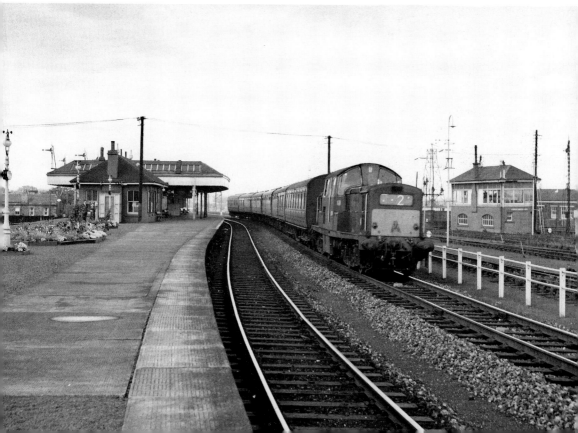

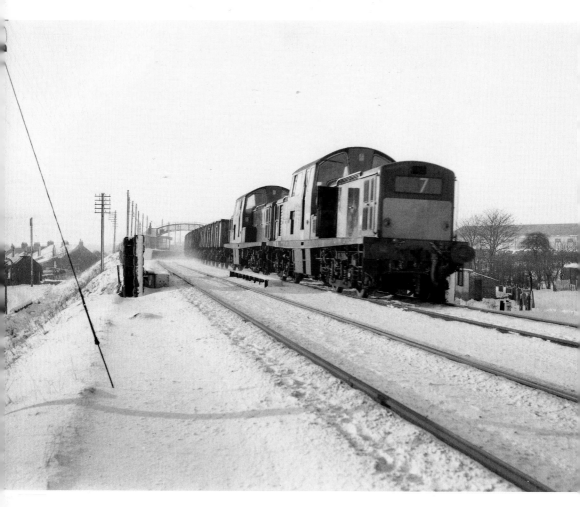

During the appalling winter of 1962/3, Clayton Type 1s Nos D8511 and D8507 pass Fauldhouse (No
on the descent of Benhar summit with an eastbound train of empty wagons. When this photogr.
was taken on 18 January 1963, the temperature was -10°C. *(W.A.C. Smith)*

11

Diesel Multiple Units (DMUs)

The first significant use of diesel-powered railcars was by the Great Western Railway in 1934. The company introduced thirty-eight diesel-mechanical railcars into their services with great success.

In the 1950s, British Railways developed an interest in DMUs because of the need to move away from the expensive and labour-intensive steam locomotive on many lines and, under BR's 1955 modernisation plan, the building of a large number of units was authorised.

The first generation DMUs were built between 1956 and 1963. Most were diesel-mechanical units consisting mainly of two-car units (but also three- and four-car sets). The first sets to be delivered were Derby and Metro-Cammell lightweight two-car units (introduced in 1954). The first generation fell into several groups – low-density (rural lines, provincial commuting), high-density (busy commuter services) and, for some local services, cross-country units (more luxurious low-density units designed for longer distance rural services), and InterCity units (substantially constructed).

At the start of the 1980s, British Railways' successors had a large fleet of inherited DMUs (hence the term 'Heritage'). They were of various designs from a range of manufacturers and BR, therefore, began to replace them with units built according to contemporary standards. These units were termed 'second generation' and had appropriate 'new product' names such as 'Pacers' and 'Sprinters' and 'Networkers'.

..

Opposite, top: Three-car cross-country unit No. W50711 (probably used on services to Bristol and Card stands in the shed yard at Salisbury sometime in 1966. These units were built at British Railwa Swindon Works and were equipped with two B.U.T. (AEC) six-cylinder engines and Cardan sl transmission. No. W50711 was one of the original build with four headcode discs/lights as used at time on steam-hauled trains. *(George Harrison/D.J. Hucknall Collection)*

Opposite, bottom: As stated in the introduction to this chapter, the first significant use of diesel-powe was by the GWR in the 1930s. Seen here is railcar No. W33W (rebuilt in 1957 to replace No. W37 No. 33 was first allocated to Worcester shed, it was then transferred to Stourbridge and, fina withdrawn from Reading in the early 1960s. *(D.J. Hucknall Collection)*

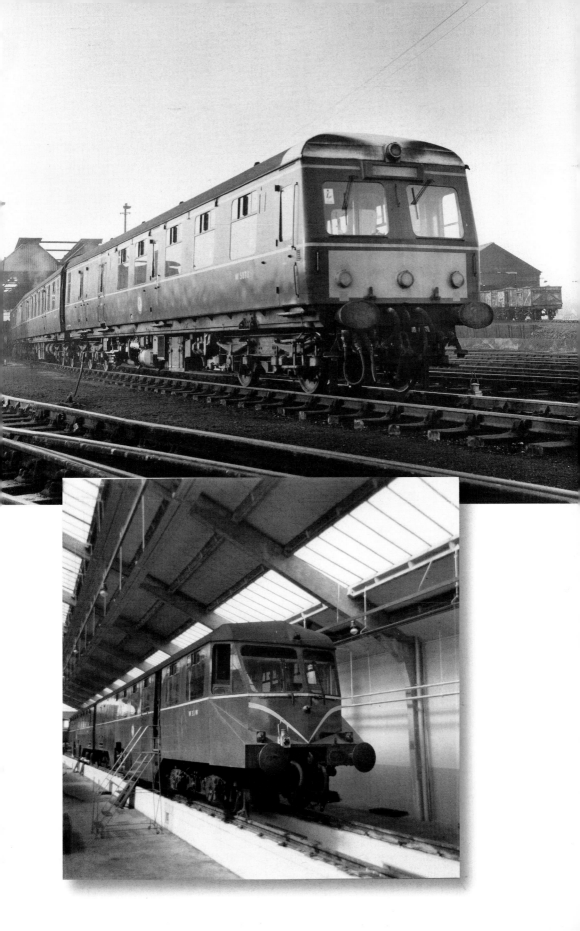

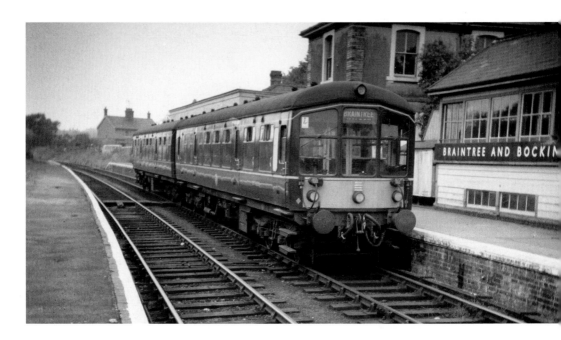

Derby Works-built brake twin unit No. E79032 is seen at Braintree station in the early 1960s, hav
travelled the Braintree branch from the main-line station at Witham. Such units were powered by t
AEC six-cylinder engines via a four-speed gearbox and a Cardan shaft. *(Ralph Clarke/D.J. Huck*
Collection)

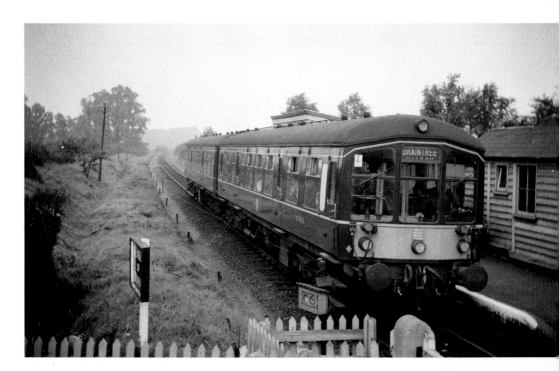

Derby twin unit No. E79032 is shown in its progress towards Braintree. This station is probably W
Notley, with Cressing the next stop. *(Ralph Clarke/D.J. Hucknall Collection)*

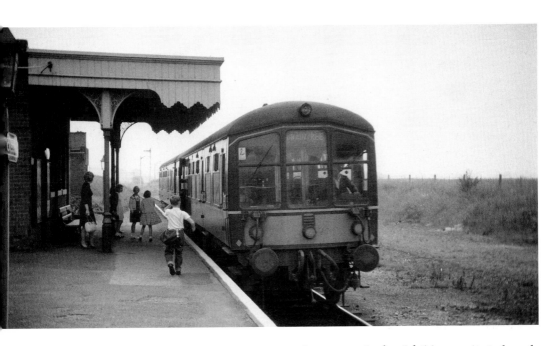

e train to Braintree has stopped at Cressing station and a group of schoolchildren waits to board.
e Derby twin unit set shown here could be coupled together and driven by one man in the leading
. To distinguish cars that could be run together, symbols were painted with a colour-code symbol.
re, the symbol is a yellow diamond. Only units having the same symbol could be coupled together.
alph Clarke/D.J. Hucknall Collection)

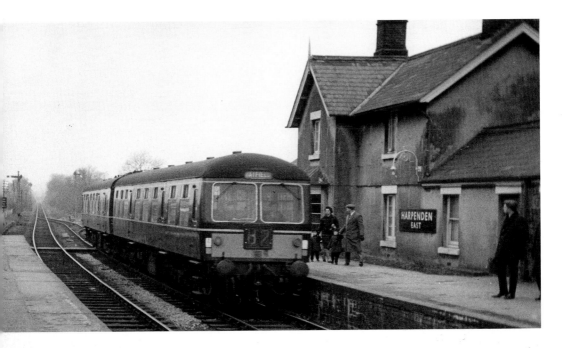

Cravens-built two-car set (later classified as Class 105/6) pauses at Harpenden East station, on the
elwyn–Dunstable line. The 105/6 sets were introduced in about 1956 for use in East Anglia but
sure of many branch lines there led to the sets being used elsewhere in the country. (D.J. Hucknall
llection)

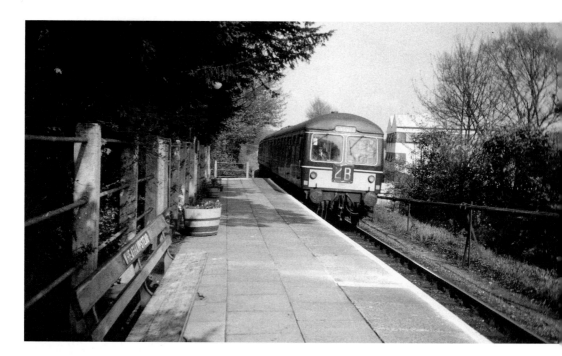

A further view of a Cravens two-car set on the former Hertford, Luton and Dunstable railway sho
the unit approaching Wheathampstead station. The station opened on 1 September 1860 and eventua
closed in April 1965. *(D.J. Hucknall Collection)*

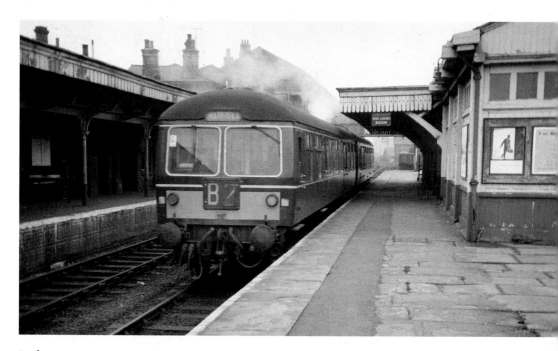

In the 1960s, many of Britain's smaller urban stations had gas lighting, chipped and peeling paintwo
and a general air of neglect. Luton (Bute Street) station was no exception. In this photograph, a Crave
two-car set is about to leave the station and continue its journey north on the former Luton, Dunstab
and Welwyn Junction Railway. On 26 April 1965, Bute Street, inevitably, was closed to passenge
(D.J. Hucknall Collection)

bably one of the
placed Cravens-built
o-car sets, originally
roduced for branch
e work in East Anglia,
nds at Ballater station
une 1965. Ballater
tion opened on
June 1866 but never
ite made the century,
sing to passengers on
February 1966.

example of the
e Waggon und
schinenbau railbuses
os E79960–79964)
t were used by BR's
stern Region on the
dley End–Saffron
lden–Bartlow branch
een here at Saffron
lden station. They
re fitted with 150hp
essing engines and the
wer was transmitted
the gearbox by a
id flywheel. The first
liveries were made to
atford depot on
March 1958.
alph Clarke/D.J. Hucknall
llection)

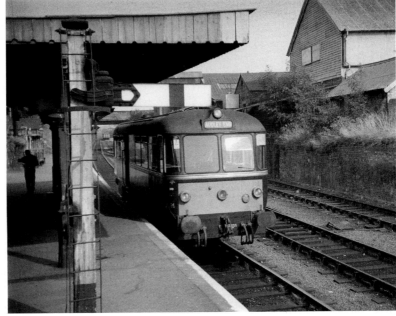

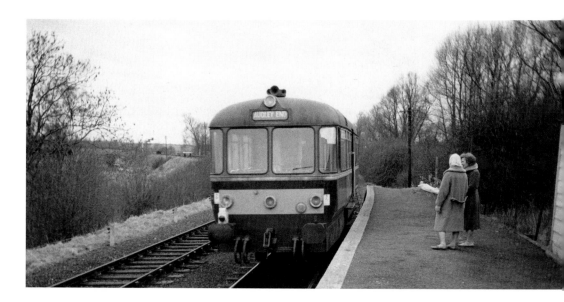

The use of railbuses on the Audley End–Saffron Walden–Bartlow branch reportedly did not please t
locals as it meant the loss of a former early-morning train at great inconvenience to local schoolchildre
Difficulties also arose trying to accommodate the prams and parcels which rural customers h
obviously been used to transporting. Here, at the Audley End branch platform at Bartlow, one of t
Waggon und Maschinenbau railbuses stands while two potential passengers reflect on its shortcoming
(Ralph Clarke/D.J. Hucknall Collection)

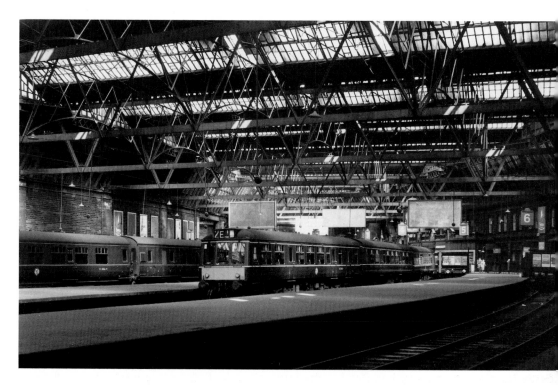

A Derby 'heavyweight' three-car unit stands at Princes Street station, Edinburgh, on the afternoon
8 May 1965. By this time, the station had lost most of its traffic and it closed on 6 September of t
same year.

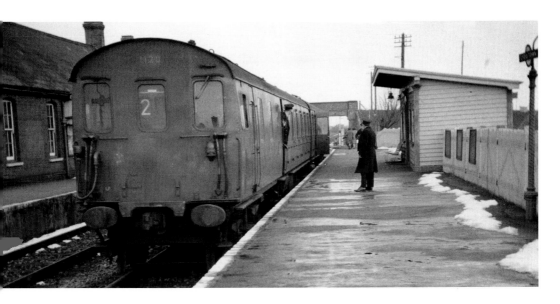

e Southern Region of British Railways introduced DEMUs (Diesel Electric Multiple Units) for use
 non-electrified lines. These units were known as 'Thumpers' because of the noise produced by their
ge, slow-revving English Electric engines. Here, a 'Thumper' stands at the Down platform at Lydd
vn on the New Romney line. The 'Thumpers' were introduced to the line in 1962 but it closed to
ssenger traffic on 6 March 1967. At the end of the platform, behind the few departing passengers, the
ly overbridge on the New Romney line can be seen. *(D.J. Hucknall Collection)*

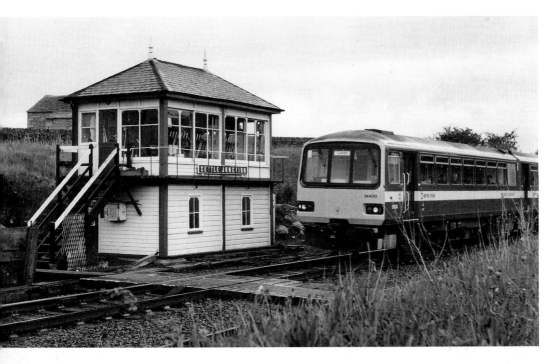

Settle Junction, the railway line divides; the Settle–Carlisle climbs to the north at a gradient of
n 100 while the Morecambe line continues on the level. At the junction is Settle Junction signal-box.
ssing the box is a 'Pacer' Class 144 (No. 144010; leading car No. 55833), one of the second generation
DMUs. The 144s were built from 1986 to 1987 by BREL-Alexander.

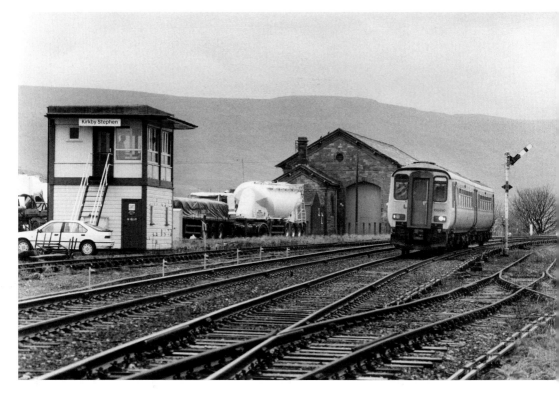

Class 156 'Super Sprinter' No. 156490 (made up of vehicles 52490 and 57490) was delivered to Nevil Hill depot in April 1989. It is seen here approaching Kirkby Stephen station on 30 December 1997. Th unit continues to operate on the northern division of British Rail but its current owners are the rollin stock leasing company Angel.

Opposite, top: Trade is brisk at Sherborne station in July 1995. The passengers are boarding a Cla 159 'Sprinter' No. 159018. Twenty-two three-car units were built for Network South East's 'West England' route from Waterloo to Salisbury, Yeovil and Exeter as replacements for the loco-haule passenger trains. No. 159018 was a unit built in 1992. Originally, one of a batch of over-ordered Cla 158s, the 158 was rebuilt by Babcock Rail. The Class 159s are maintained at Salisbury TMD.

Opposite, bottom: A Class 155 'Super Sprinter' two-car unit, No. 155315, stands at Platform 4 of Salisbu station on 18 August 1991 with a train to Cardiff. The Class 155s were two-car units built by Briti Leyland in the second half of the 1980s for longer-haul services than the Class 150 on which they we based.

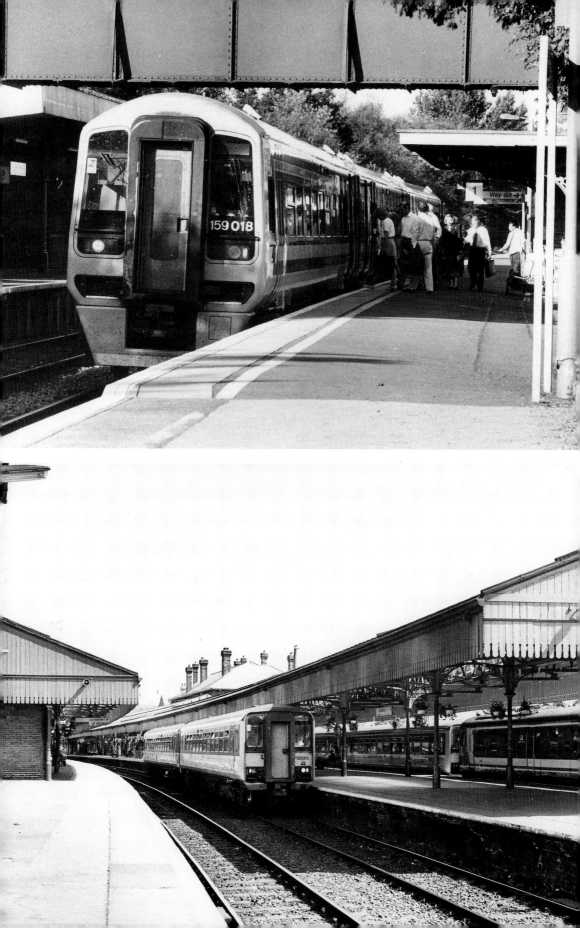

A Class 156 'Super Sprinter', No. 155318, one of the second-generation DMU types, enters Truro stati on 10 August 1991. It was running on a Plymouth–Penzance service and, according to the timetab would continue its journey at 11.48 a.m.

Opposite: Having passed Rainbow Hill tunnel on its way to the station, Class 150 'Sprinter' No. 150₂ approaches Tunnel Junction signal-box on 27 July 1999 with a train from Birmingham New Str station to Worcester.

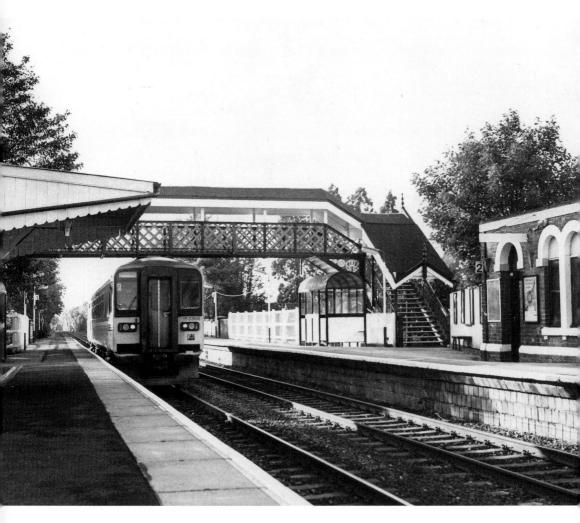

Said to be 'disliked' by passengers, the Class 153 single-car units were converted from Class 1
two-car sets by adding a driving cab to what had been the inner-end of the constituent cars. He
No. 153366 pauses at Codsall station on the evening of 12 September 1995.

12

The Shunters

British Railways in the late 1950s and throughout the 1960s had a large number of 0–6–0 shunting locomotives built, not only in their own workshops, but by a range of manufacturers including Hunslet, the North British Locomotive Co., Barclay and others. The British Railways-manufactured locomotives were particularly numerous. As it later became known, the Class 08 was the standard BR diesel-electric shunter with almost 1,000 units being produced.

The duties of shunting locomotives were wide indeed – they acted as station pilots and shunted in locomotive depots and carriage sidings. They even hauled brake-van rides for special events.

Eventually, the changing nature of rail traffic in Britain rendered them irrelevant. Freight trains are now mostly fixed rakes of wagons and passenger trains are usually multiple units, neither requiring shunting locomotives. Surprisingly, however, there are still almost 100 examples working in Britain. Quite a few are on preserved railways but many still work sidings for some remnants of British industry.

..

Opposite, top: Work over for the day, Class 08 shunters Nos 08749 and 08871 stand at Tinsley Tracti and Maintenance Depot. Next to No. 08749 is Class 09 shunter No. 09013. The Class 09s were re-gea 08s which were capable of travelling at speeds of up to 27mph and could be used for short-dista freight trips. No. 09013 was one of the original batch of 09s.

Opposite, bottom: Taken from the overbridge that leads to Dock Gate 20 of Southampton Contai Terminal in June 2001, this photograph shows Class 57 No. 57009 *Freightliner Venture* and a Class No. 47292, in the company of a superbly clean Class 08 shunter, No. 08585, at the Freightliner l stabling point. A very thoughtful addition to the Class 08's bufferbeam was the shedplate for (Southampton Docks in the days of steam).

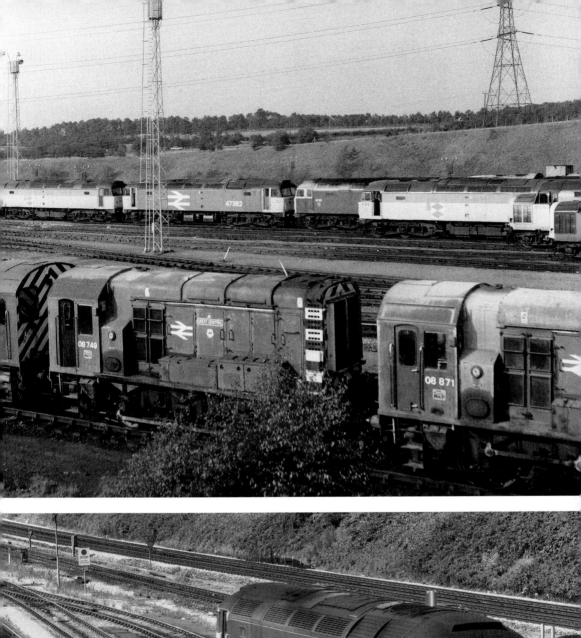

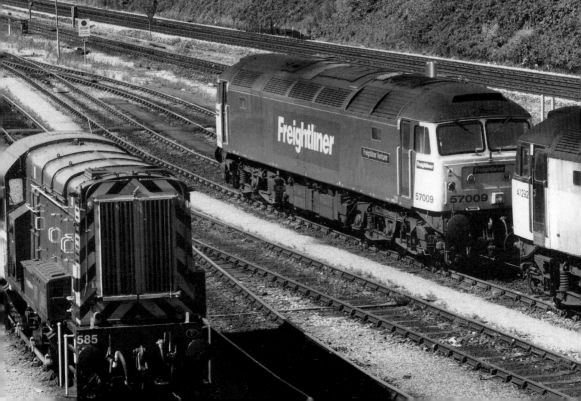

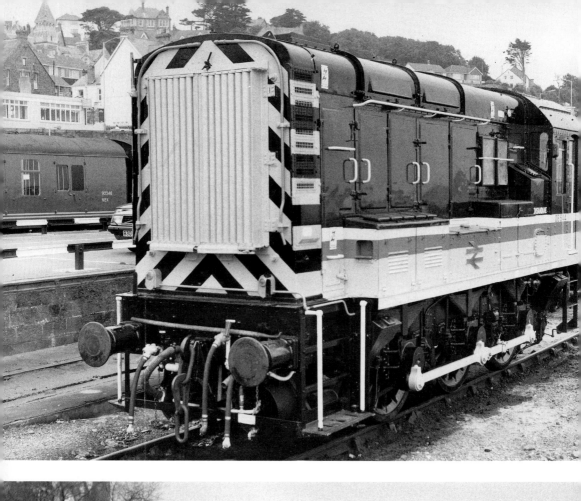

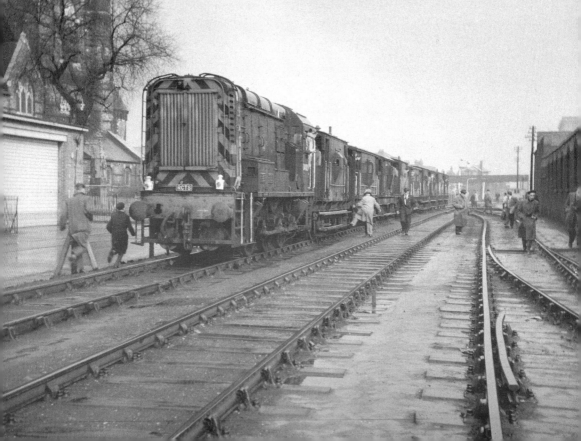

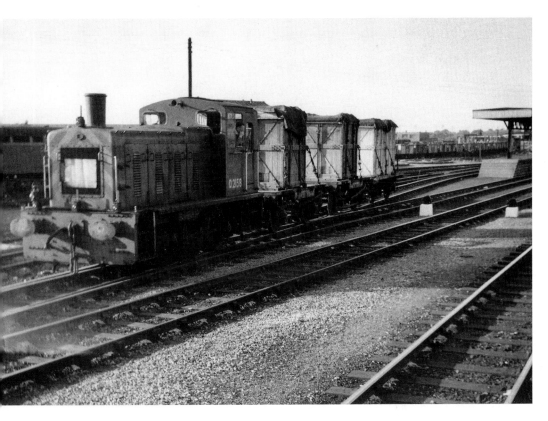

Gardner-engined shunter (later BR Class 03) was one of the most successful of the 0–6–0 diesel-*hanical shunters. Between 1957 and 1962, some 230 examples were built at either Swindon or *caster Works. Here, seen standing in the evening sun at York station on 3 June 1963, No. D2158 *ses while marshalling a train of pallets.

osite, top: Repainted in InterCity colours, Class 08 No. 08644 (unofficially named *Ponsandane*) is *a in the sidings at Penzance station on 29 July 1991.

osite, bottom: An unusual use of diesel shunter No. D4192 was to haul a string of enthusiast-carrying *e-vans for the Silvertown Tramway Railtour of 30 March 1963 which was organised by the RCTS *don branch. The route started at Stratford (Low Level) and went via Stratford Southern Junction * Thames Wharf Junction to North Woolwich before moving to Silvertown and the Tramway. *. Hucknall Collection)*

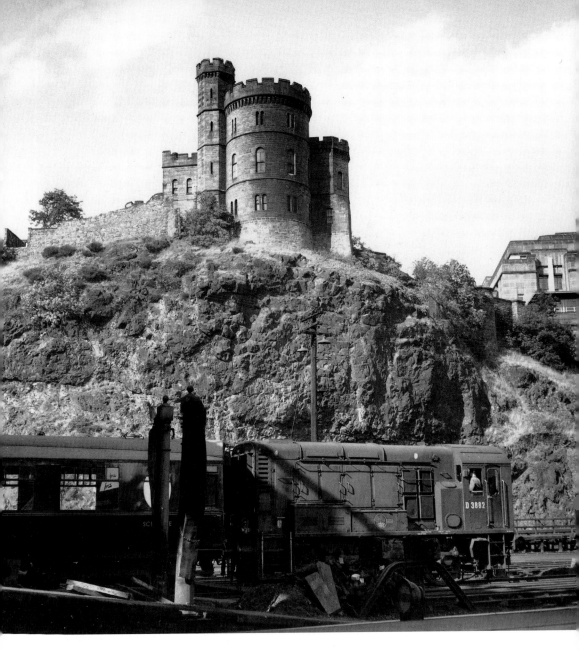

While shunting empty carriage stock, what was then known just as 'a diesel shunter', No. D3882 pau[at the south end of Waverley station on 29 August 1964. Dominating the photograph is the Governc House (described by W.A.C. Smith as 'a rather whimsical creation towering above the platforms') the time, marshalling of coaching stock and parcels vehicles was an essential duty at Waverley.

Opposite, top: Class 08 shunter No. 08732 comes off the Moffat Mills branch at Clarkston (Airdrie) w grain wagons from Inverhouse Distillery on 24 July 1974. The shunter and its train are joining Bathgate line. As a note on the Bathgate line, it lost its passenger service in 1956 but it is to be reope by 2011 as an additional route between Glasgow and Edinburgh. *(W.A.C. Smith)*

Opposite, bottom: A line of 0–4–0 diesel mechanical shunters, Nos D2411, D2422 and D2444, were in use at Perth shed on Sunday 16 August 1964. The class (British Railways' Class 06) was buil Andrew Barclay, Kilmarnock, between 1958 to 1962. The company were working in accordance v BR's request for a 'powerful loco' with a short wheelbase, capable of working on the main line. N examples were withdrawn in 1968.

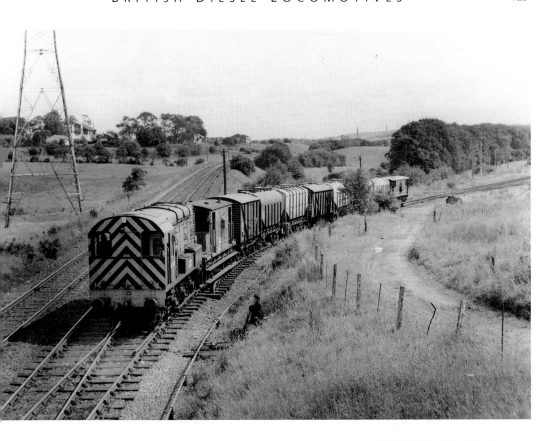

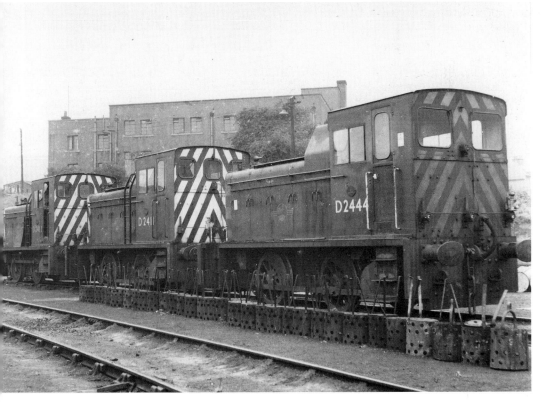

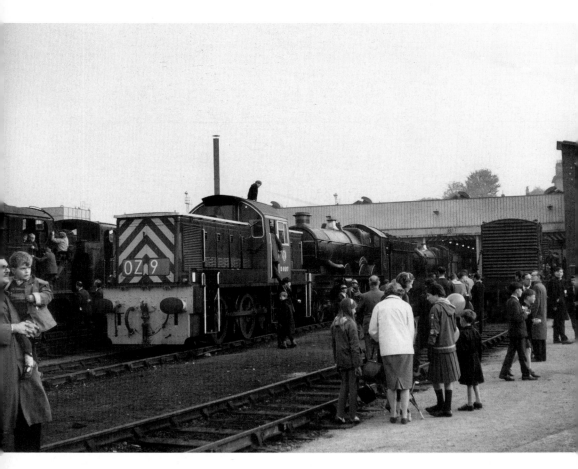

This example of a Class 14 diesel shunter, No. D9517, is photographed at an open day at Bristol I
Road depot. Fifty-six Class 14s were built at Swindon for yard shunting, trip working and sh
distance freights. Unfortunately, they were introduced at a time when Richard Beeching was clo
lines and generally eliminating most of the work they may have done. It has been said that
Class 14 was the biggest white elephant of the BR traction fleet.

13

Heavy Freight Classes

BR Class 56

In the mid-1970s, oil crises occurred as price and supply were used by OPEC as devices to punish the West for its actions in the Middle East. This resulted in a perceived upsurge in the amount of coal to be moved by rail in the UK. The Class 56 locomotives were regarded as an immediate solution to the expected increase in 'merry-go-round' colliery power station workings and an order was placed with Brush for suitable locomotives. Because of the limited development time, the 56s were based on the Class 47 body-shell, fitted with a Ruston-Paxman engine developing 2,423kW (3,250bhp) and the first thirty units (Nos 56001–56029) were built by Brush's Romanian associate. Such were the faults and problems (including shipping damage) with the first batch, the next 105 locomotives were built by BREL in Doncaster while the remaining twenty were constructed at Crewe.

Although strong and capable locomotives, the 56s required significant maintenance and could not compete with the Class 66 in terms of availability and servicing costs. Most examples were withdrawn by EWS in March 2004 although some examples were reinstated.

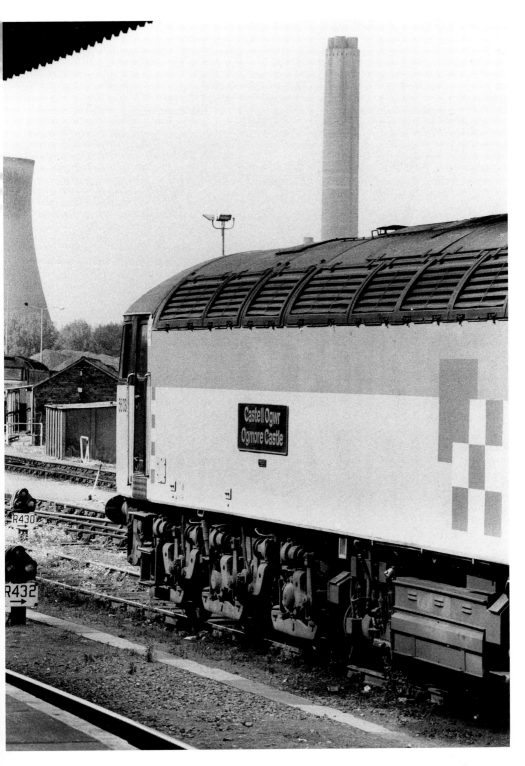

No. 56034 *Castell Ogwr/Ogmore Castle* was one of the group of Class 56s built by BREL at Doncaster. It is seen here at Didcot station on 25 August 1991. The decal on the locomotive's body side (blue and yellow squares) indicated that it was assigned to the TrainLoad Construction Sector pool of locomotives.

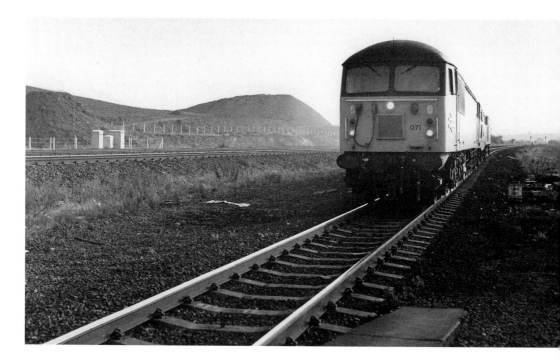

On the evening of 25 August 1990, Class 56 No. 56071 approaches the remains of Platform 1 of Parkg
and Rawmarsh railway station. The station was closed on 4 January 1968 together with others on
former North Midland Railway.

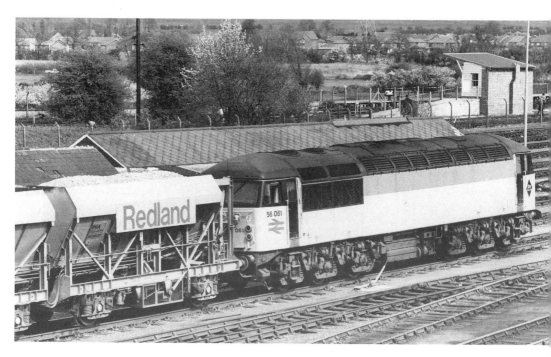

Class 56 No. 56061 stands in Didcot sidings on 20 April 1991 with a train of aggregate hoppers. In l
2003, following the acquisition of parts of the railway system by a consortium led by the Americ
company Wisconsin Central, a drastic reduction in the Class 56 fleet took place and, by the end of 20
only ten units remained.

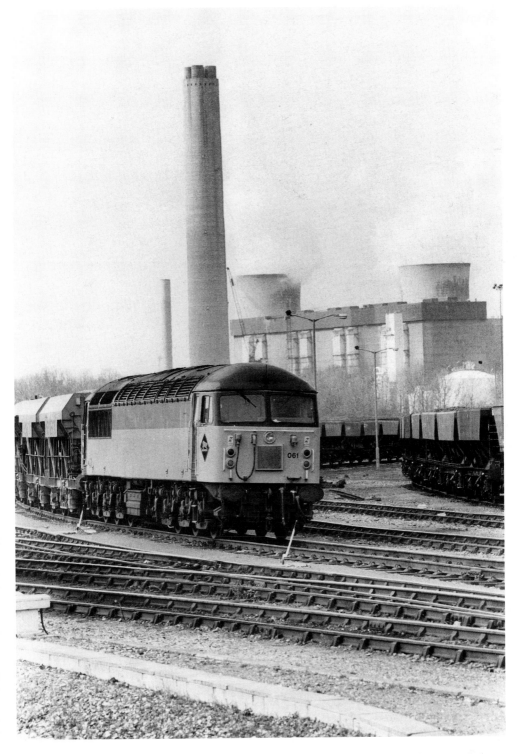

A further view of Class 56 No. 56061 at the head of a Redland's aggregates train at Didcot northern sidings on 20 April 1991.The unmistakable background shows Didcot 'A' power station with its 198-metre tall chimney and cooling towers. The Class 56 appears to be carrying a depot plaque that shows a tiger. This indicated that it was allocated to Leicester.

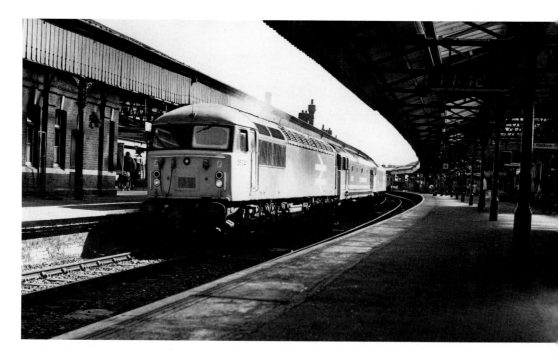

Class 56 No. 56041, coupled to a Class 50 and a Class 47, is seen on the platform loop at Salisbury station on 28 August 1989. No. 56041 subsequently reversed into the West bay. No. 56041 entered traffic in February 1978 and saw service with EWS.

The presence of Class 56 No. 56041 in the West bay at Salisbury station on 28 August 1989 is obviously intriguing a bystander.

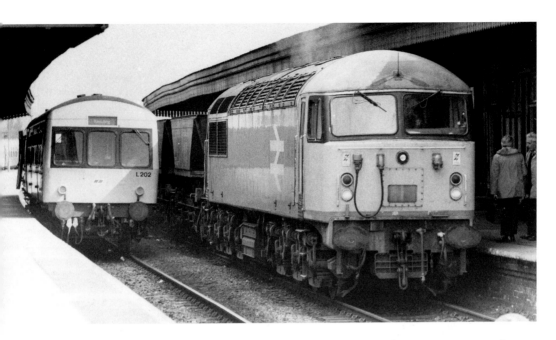

unidentified Class 56 stands at Platform 3 of Didcot station on 20 April 1991. It appears to have a
l hopper train, possibly for Didcot power station, attached. Standing at Platform 4 is a shuttle train
Reading.

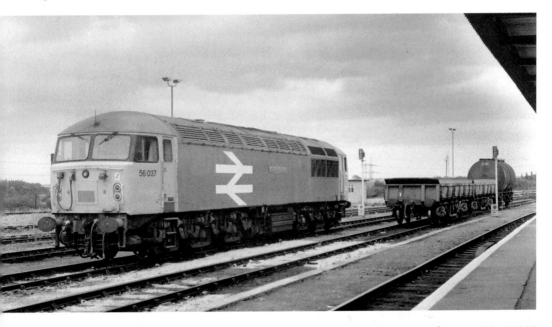

ss 56 No. 56037 *Richard Trevithick* is shown in Didcot sidings on 31 July 1989. At the time, No. 56037
s in the Railfreight livery of grey with the large double-arrow logo and yellow cabs. This livery
l persisted until the late 1980s when BR freight operations were sub-divided into sectors. Many of
Class 56 carried names. They tended, however, to reflect their activities. For example, many were
ned after collieries while others had the names of power stations. No. 56037, however, was named
r a Cornish mining engineer who built a high-pressure steam engine. In August 1999, No. 56037
s acquired by EWS and repainted in its colours. In March 2004, many Type 56s were withdrawn.
 subsequent history of No. 56037 is not known.

BR Class 58

The Class 58 was introduced in 1982. It was a Co-Co diesel designed for heavy freight haulage. Built by BREL at Doncaster, it was well designed with a simple basic construction and with interchangeable sections. Some fifty examples were built but the perceived market (coal traffic) was about to be severely limited. The 1984/5 miners' strike with subsequent pit closures meant that the intended work had dramatically declined although all fifty members of the Class were assigned to the TrainLoad Coal Sector. In their day, the Class 58s were powerful and capable freight locomotives and, by the mid-1990s, when withdrawals of the class began, they had become one of the most reliable types in the British diesel fleet.

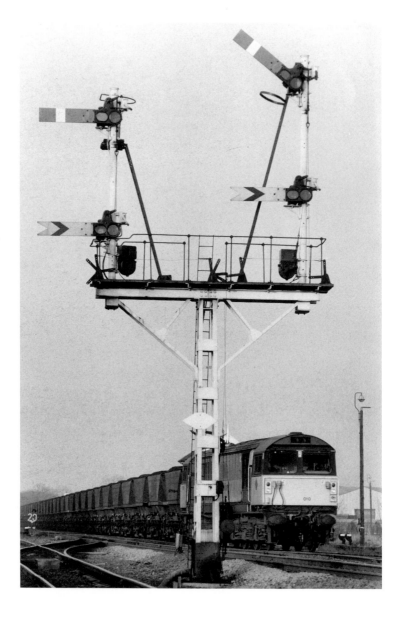

ove: Doncaster Works was the name applied
Class 58 No. 58020. The locomotive entered
vice in November 1984 and, after just
enteen years of working, it went into
rage (September 2002). According to
ords, its last task was hauling a train from
gness to King's Cross.

ht: Reflecting the planned use of the
omotive, Class 58 No. 58049 carried the
ne *Littleton Colliery* with the addition of
itish Coal' to one corner. No. 58049 entered
ffic in December 1986 and was stored in
y 2002. According to records, its last task
s to haul 8Y23 Hoo Junction–Hither Green
27 May 2002.

osite: Class 58 No. 58010 is seen
roaching the balanced bracket signal
r Shireoaks East Junction signal-box
h what appears to be a 'merry-go-
nd' coal train on 13 January 1997.
58010 had entered service in February
4 and it was put into storage in
ember 1999.

BR Class 60

In the 1980s, British Rail identified a requirement for a Type 5 diesel locomotive for use in its TrainLoad Freight Sector. An order for 100 locomotives was placed with Brush Traction. By 1990, the locomotives began to be introduced on the main line. The 100 locomotives were based at Toton and their duties were split between the Load Haul, Transrail and Mainline Freight divisions of BR. Initially, they worked mainly on aggregate traffic, replacing Class 56 and 58 locomotives. Following the privatisation of BR, the units came under the control of EWS. In the period 2004 to 2007, between 50 and 75 per cent of the fleet was out of action at any given time. At the time of writing, many of the class have been stored, with only fifteen units in operation at a time.

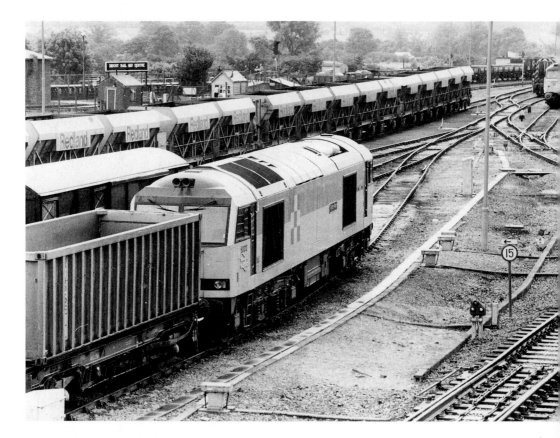

On the afternoon of 9 June 1991, Class 60 No.60012 *Glyder Fawr* stands in the northern sidings at Didcot with a train of aggregate empties owned by D.B. Russell (Construction) Ltd. In 1989, Railfreight named members of Class 60 attached to the construction and metals sector after British mountains.

h Didcot cooling towers in the
background, Class 60 No. 60012
der Fawr looks impressive in
Railfreight livery.

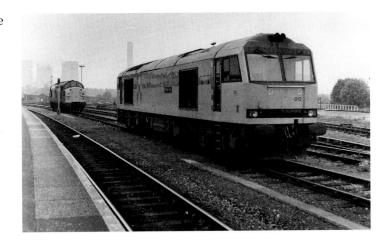

n in Didcot Yard northern
ngs Nos 1 and 2 are Class 66
66158 (in EWS livery) and
ss 60 No. 60069 *Humphry*
y. The No. 2 end of the
ss 60 can be seen with, close
ail-level, the locomotive's
tacle jumper plate and, just
ront of the visible wheel, the
d box. No. 66158 (sub-class
0) was one of the first 250
omotives ordered by EWS
n General Motors' Electro-
tive Division and built in
idon, Ontario, in August 1999.

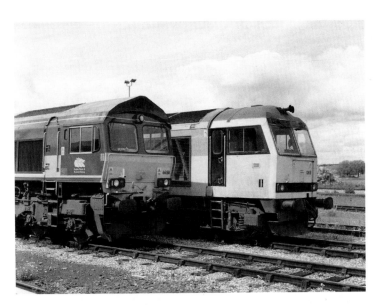

air of Class 60 locomotives,
s 60036 and 60022, are
wn in Didcot Yard northern
ing No. 1. No. 60022 *GEFCO*
ered service in January 1991
Thornaby with TrainLoad's
tals Sector. No. 60036 had
ered service the following
e, also at Thornaby.

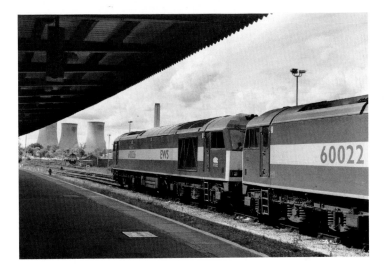

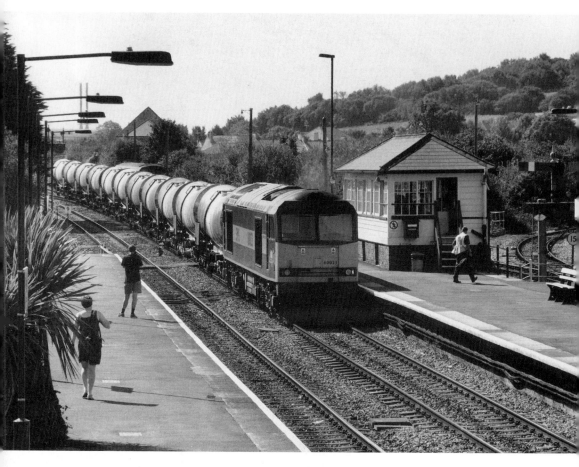

A Class 60 locomotive, No. 60023 (formerly named *The Cheviot* but the nameplates were removed
1997), pauses by the signal-box on the Up side of the island platform at Par with its load of china c
The date was 1 September 1999.

14

BR Class 33

These locomotives were known originally as the BRCW (Birmingham Railway Carriage and Wagon Co.) Type 3. Ninety-eight BRCW Type 3s were built for the Southern Region, their original numbers being D6500–97. No. D6500 entered service in December 1959.

The BRCW Type 3/BR Class 33 appeared in three different forms. Eighty-five (Nos D6501–85) were built as standard locomotives (Class 33/0) while Nos D6585–97 were built to the Hastings line gauge. Between 1965 and 1967, nineteen Class 33 locomotives were modified to work as push-pull units following the electrification of the Waterloo–Weymouth line as far as Bournemouth.

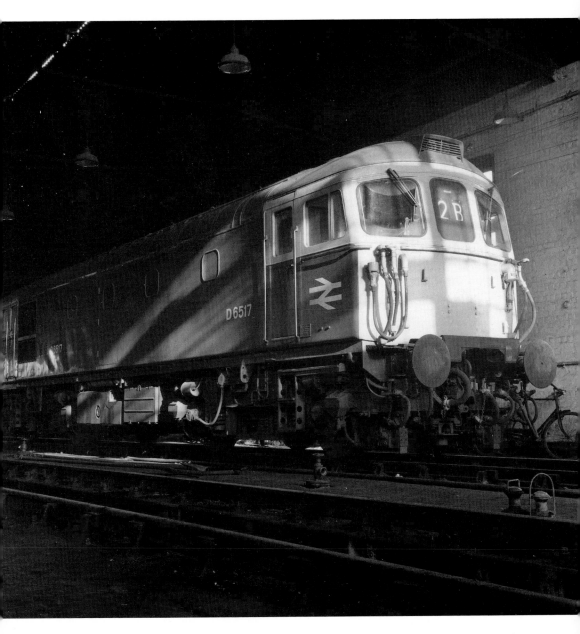

...otographed inside Salisbury shed sometime between 1965 and 1967, here is BCRW Type 3 (later ...own as Class 33) No. D6517. This locomotive was one of the nineteen modified for push-pull work ...tween Bournemouth and Weymouth. The modified locomotives, as can be seen, had high-level ...mpers, three-piece end handrails, large diameter Oleo buffers and gangway vestibule rubbing plates. ... D6517 was built in July 1960 and was subsequently renumbered No. 33105. It was withdrawn in ...tober 1977. *(George Harrison/D.J. Hucknall Collection)*

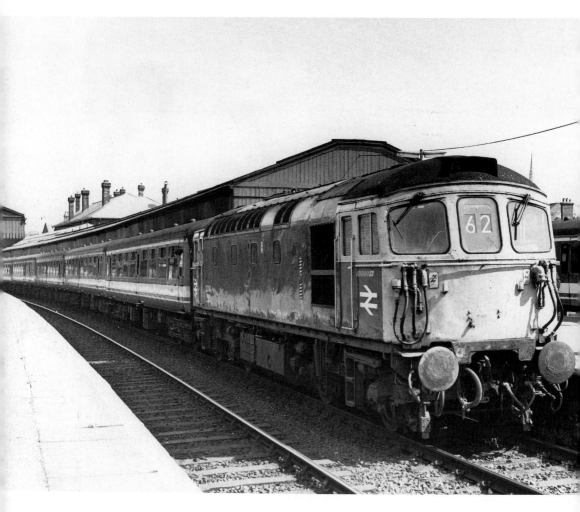

Class 33/1 No. 33114 departs from Platform 4 at Salisbury station on 18 August 1991 with an afterno train for Exeter. The 33 was built in November 1960 as D6532 and had been fitted for push-p operations on the Weymouth–Bournemouth trains prior to the electrification of the line.

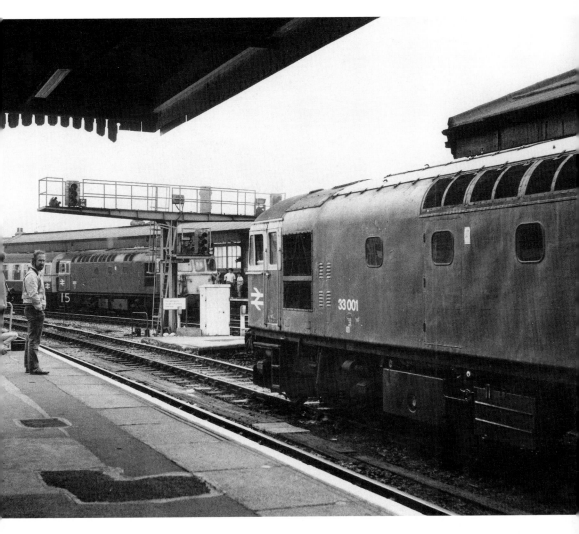

...atively little interest is being shown in the Class 33s at Salisbury station on 20 June 1987 (the ...action was *Flying Scotsman* which appeared later). An unidentified Class 33 stands in the East Bay ...tform (Platform 6) while No. 33001 stands at Platform 2. No. 33001 was one of a large number of ...Class 33s that were withdrawn from service in the 1990s, mainly because they were surplus to ...erating requirements.

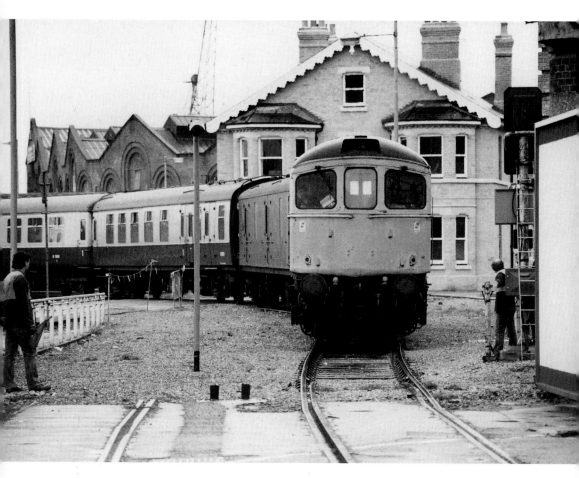

Class 33 No. 33005 leaves Southampton East Docks on 3 May 1986 with the 10.18 to Waterloo. *(D.J. Hucknall Collection)*

Opposite: The Bournemouth–Waterloo line of the Southern Region was electrified in July 1967. extension to Weymouth, however, was not completed until 1988. The result of this was that Waterl Weymouth trains between Bournemouth and Weymouth had to be locomotive-hauled. Here, unidentified Class 33 is seen leaving Poole for Weymouth with a train of five coaches (the trains w divided at Bournemouth). In the background, a Class 47 and its train wait in the Up siding.

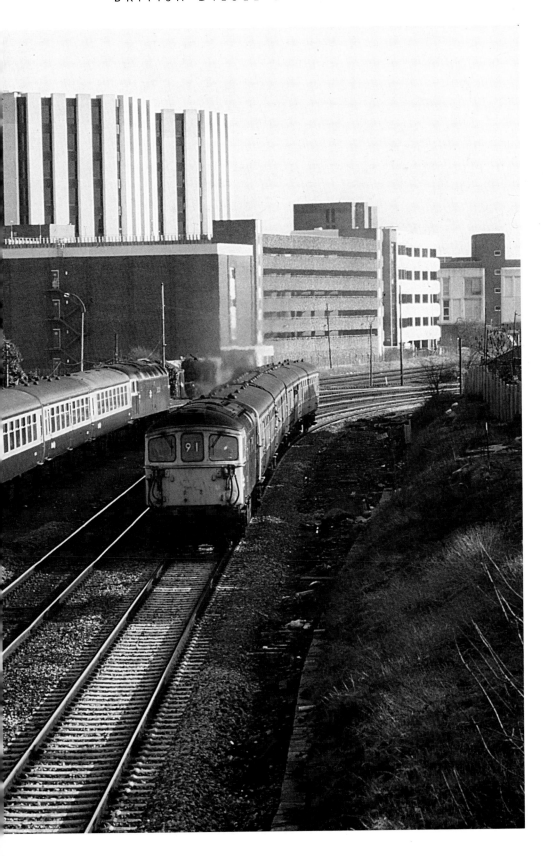

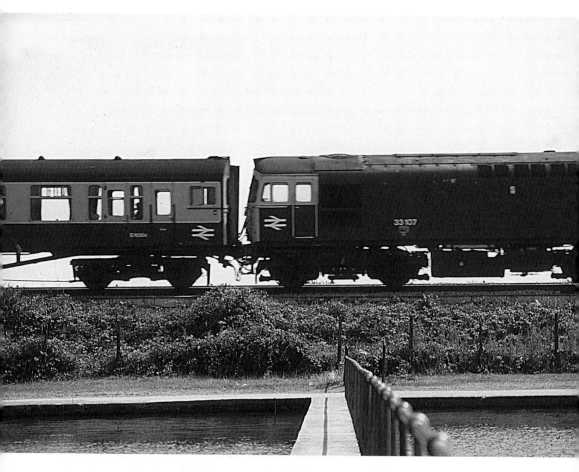

After rounding the curve out of Poole station, Parkstone bank begins. At this point, to the south
the line, was the land reclaimed from Parkstone Bay. To the north was the boating lake. Here, Class
No. 33107 is seen, from the lake side of the line, pushing the Weymouth–Bournemouth portion c
Waterloo-bound train at the start of the climb.

Opposite: Judging by the haze from its exhaust, an unidentified Class 33 is just at the start of its cli
to Branksome. This photograph was taken in the summer of 1983 and the push-pull activities for
Bournemouth–Weymouth line were to continue for a further five years.

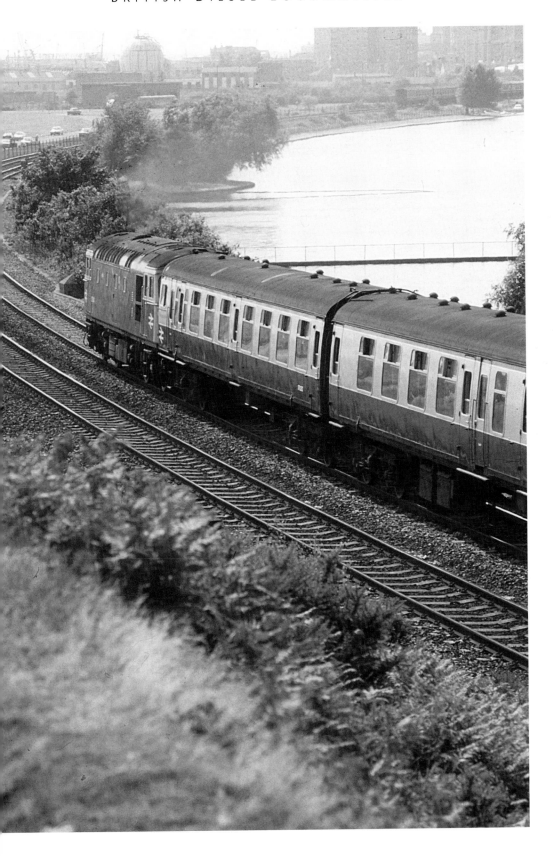

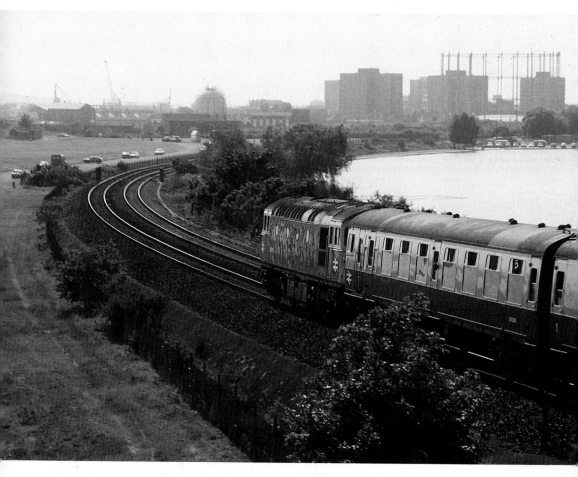

The Weymouth-bound portion of a train from Waterloo approaches the curve leading to Poole stati

Opposite: Class 33 No. 33109 is seen leaving Poole on its way to Weymouth. The make-up of the twe
coach Waterloo–Bournemouth–Weymouth trains was such that only the rear four coaches of the Do
trains were powered (forming an EMU). The push-pull equipment fitted to the 33/1 Class removed
necessity for the locomotive to run round its train at the terminus so it could either push or pull its 4
loads. No. 33109 is now preserved and bears the name *Captain Bill Smith RNR*.

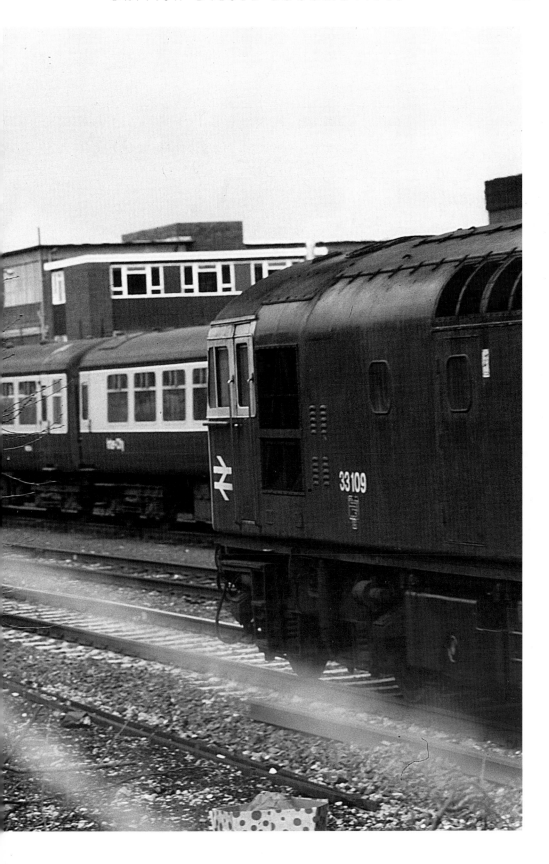

An unidentified Class 33/1 pushes its 4TC + 4TC load on Parkstone bank. On reaching Bournemou the Class 33 will be uncoupled and wait for a Down train. The 4TC + 4TC would then be joined further powered 4TC for its onward journey to Waterloo.

15

The Bo-Bo Electro-diesels/
Class 73

The Bo-Bo electro-diesel locomotives were introduced in 1962. They were fitted with both English Electric four-cylinder diesel engines (4SRKT mkII) and four English Electric 400hp traction motors. The locomotives could, therefore, work either directly from a 750DC third-rail supply or, when this was not available, with the diesel engine supplying the traction motors, though at greatly reduced power. This made them very versatile.

There were forty-nine locomotives in the class, the first batch (Nos E6001–E6006) were built at Eastleigh. The second batch (forty-three locomotives) was built later at BR's Ashford Works.

Although much reduced in number, the versatility of the locomotives has meant that they continue to be used by several companies including Eurostar, GB Railfreight and Network Rail. Other companies, including EWS, Merseyrail and South West Trains, no longer operate these locomotives.

..

Opposite, top: On 8 June 1968, the Bulleid Commemorative Railtour took place, following the r‹ Waterloo–Brighton–Havant–Liss–Guildford–Waterloo. Various locomotives were used over the sec‹ and Bo-Bo electro-diesel No. E6048 was in charge of the Liss–Haslemere–Guildford leg. No. E6048 became Class 73 No. 73141 and, although withdrawn from service in March 1999, it seems to be s‹ at York. *(George Harrison/D.J. Hucknall Collection)*

Opposite, bottom: Class 73 No. 73142 *Broadlands*, appropriately, is in wonderful condition on 22 M‹ 1985 as it is being used to carry Her Majesty the Queen on her way to the opening of Eastleigh Station. The locomotive and its train are seen here at Shawford, approximately 5 miles from Eastl‹ *(D.J. Hucknall Collection)*

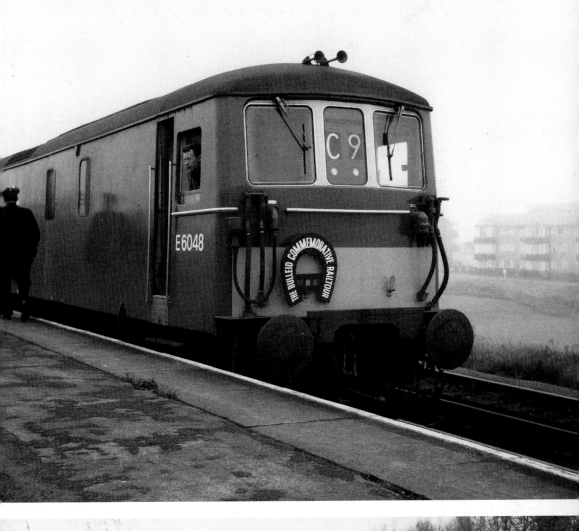

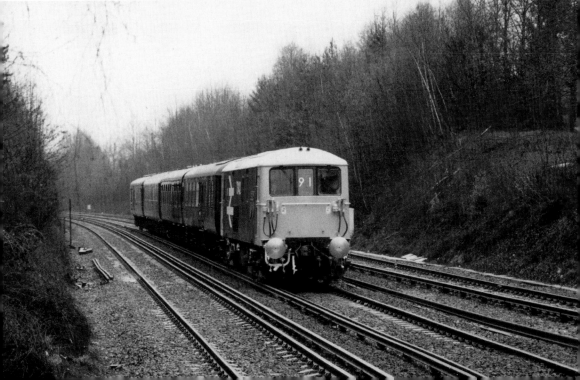

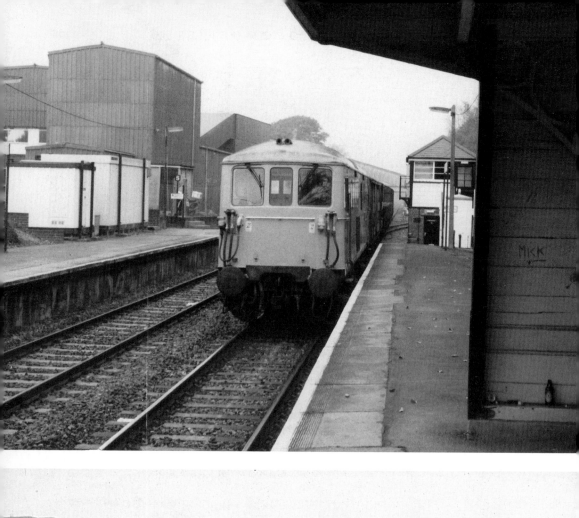

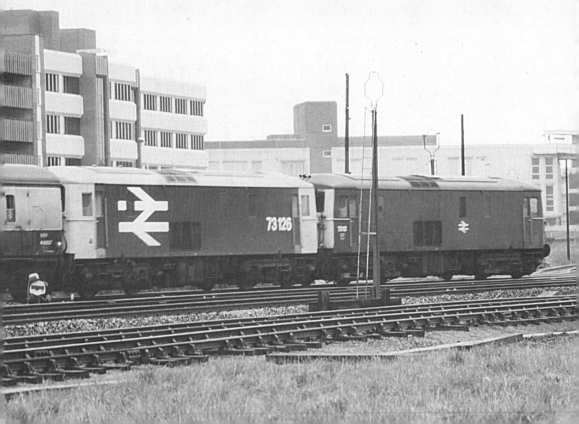

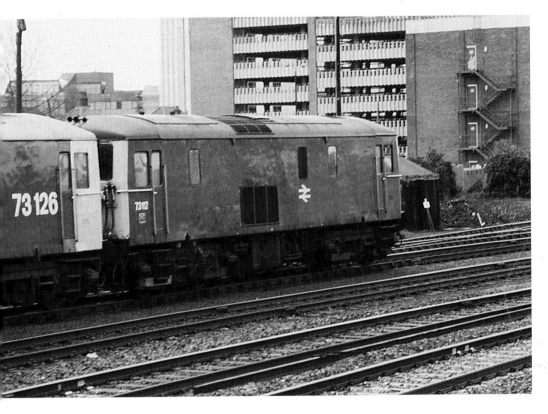

ss 73s Nos 73112 and 73126 stand in the reception sidings at Poole.

osite, top: Class 73 No. 73101 is passing Botley station on the Down Portsmouth line on 16 November 4. The train is heading to Fareham and the line to Bedenham. *(D.J. Hucknall Collection)*

osite, bottom: A pair of Class 73s, Nos 73126 and 73112, both in BR blue livery, stand in the reception ngs opposite the signal-box (formerly Poole 'B' signal-box) at Poole. No. 73126 was originally E6033 and No. 73112 was E6018. No. 73112 appears to be still in service while No. 73126, although hdrawn in January 1999, still has a role as a training locomotive.

More Engine Sheds in Camera

David Hucknall

ISBN 978-0-7509-4585-1

£19.99 Hardback 263x194mm

With a fascinating selection of over 200 engine shed images, David Hucknall shows the full range of activity on-shed throughout Great Britain, from Penzance to Polmadie and beyond. Including shed plans and extracts from contemporary logs that list the engines on-shed, this book is essential reading for all rail enthusiasts.

Diesel Decade: The 1980s

Roger Siviter

ISBN 978-0-7509-4340-8

£19.99 Hardback 263x194mm

The 1980s was, in many ways, the 'Golden Age' of diesel locomotive-hauled trains on British Railways. In this collection, Roger Siviter takes a nostalgic trip down memory lane with a series of photographic essays, including Class 40s at work, Deltics, seaside days, city stations, peaks on the Midland, freight trains much more – a must-have for diesel enthusiasts.

Rex Conway's Steam Album

Rex Conway

ISBN 978-0-7509-4626-1

£19.99 Hardback 263x194mm

With 300 outstanding photographs taken from his extensive archive, join Rex Conway in exploring Britain during the golden years of steam. Featured here not only the steam engines themselves – A4s, 'Atlantics', 'Kings' and 'Duchess to name but a few – but also many station views capturing the distinctive railway architecture in the heyday of steam travel.